Master Posing Guide

for Wedding Photographers

Bill Hurter

AMHERST MEDIA, INC. ■ BUFFALO, NY

ABOUT THE AUTHOR

Bill Hurter has been involved in the photographic industry for the past thirty years. He is the former editor of *Petersen's PhotoGraphic* magazine and currently the editor of both *AfterCapture* and *Rangefinder* magazines. He has authored over thirty books on photography and hundreds of articles on photography and photographic technique. He is a graduate of American University and Brooks Institute of Photography, from which he holds a BFA and Honorary Masters of Science and Masters of Fine Art degrees. He is currently a member of the Brooks Board of Governors. Early in his career, he covered Capital Hill during the Watergate Hearings and worked for three seasons as a stringer for the L.A. Dodgers. He is married and lives in West Covina, CA.

Copyright © 2009 by Bill Hurter.
All rights reserved.

Front cover photograph by Cherie Steinberg Coté.
Back cover photograph by JB and DeEtte Sallee.

Published by:
Amherst Media, Inc.
P.O. Box 586
Buffalo, N.Y. 14226
Fax: 716-874-4508
www.AmherstMedia.com

Publisher: Craig Alesse
Senior Editor/Production Manager: Michelle Perkins
Assistant Editor: Barbara A. Lynch-Johnt
Editorial Assistance from: John S. Loder, Charles Schweizer

ISBN-13: 978-1-58428-251-8
Library of Congress Control Number: 2008942236
Printed in Korea.
10 9 8 7 6 5 4 3 2 1

Table of Contents

PHOTOGRAPH BY MARK NIXON.

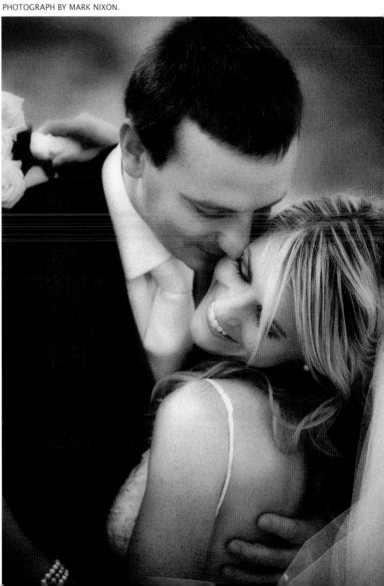

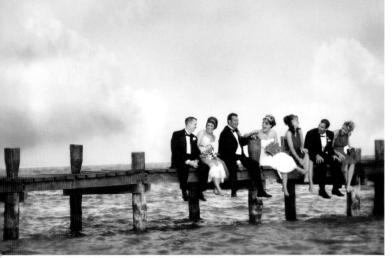

PHOTOGRAPH BY JB AND DeETTE SALLEE.

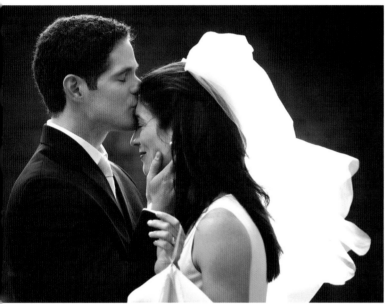

PHOTOGRAPH BY GREG GIBSON.

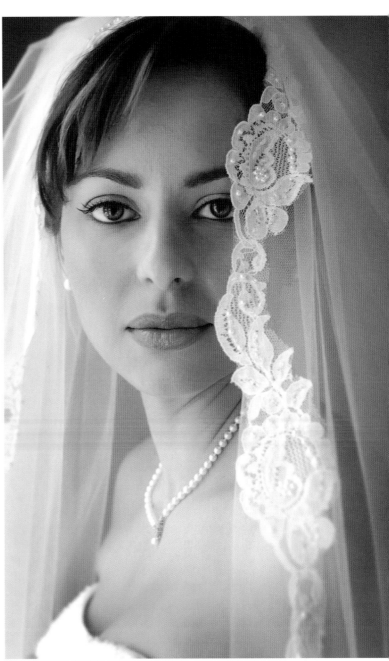

PHOTOGRAPH BY MICHAEL O'NEILL.

Introduction

It's quite simple, really. The reason a professional photographer poses a subject, whether it's a bride or a high-school senior, is to idealize the person and to reveal their uniqueness as an individual. Additionally, even more than lighting or composition, posing helps to reveal those characteristics that are unseen by the eye but experienced through the emotions—qualities like strength, honesty, vulnerability, and inner beauty. Failing to pose the subject means leaving to chance these subtleties of their appearance in the image. This would make success randomly achieved, at best.

In the early years of photographic portraiture, formal posing was an absolute necessity. Extremely slow films, equally slow lenses, and a lack of artificial light sources necessitated long exposures. Headrests, known as "immobilizers," were even used to minimize subject movement for these exposures, which could be several minutes long. The resulting poses were stiff and unnatural and the expressions were at best grim.

As photography progressed, those long exposures became a thing of the past. Poses and expressions, accordingly, became increasingly expressive and natural. But with this freedom, there was a loss—a loss of the idealization achieved by attentive, well-executed posing. As we'll see in this book, however, that does not need to be the case. Even in fast-paced situations, like most weddings, there are opportunities to balance posing and idealization with spontaneity and the capture of genuine emotion.

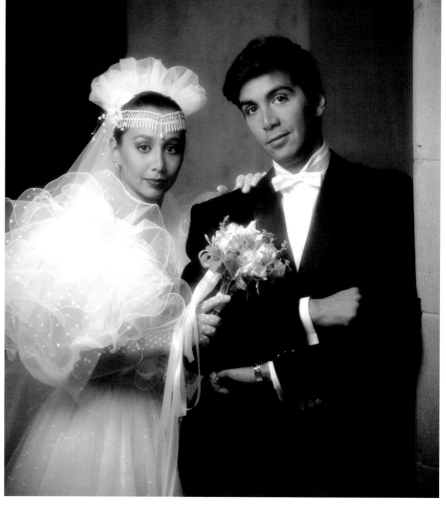

This is a formal portrait made by Laszlo of Montreal, a traditional portrait artist from Canada who has an unbelievably fine reputation. Notice the exquisite posing and the intentional way each feature of the couple—the hands, fingers, etc.—all contribute to the formal status of this portrait. Despite the formality, however, the expressions are unique to the person and not stereotypical in the least.

Sometimes the bridal portrait is reduced to a mere gesture, as was done here by Ryan Schembri. The dance of the veil is evocative and full of life—exactly what today's brides crave.

There are opportunities to balance posing and idealization with spontaneity.

Wedding Photography: Then and Now

In the earliest days of photography, weddings were photographed in styles that captured the bride and groom in stuffy, overly formal poses. Even with the emergence of the wedding album, which incorporated group portraits of the wedding party and the bride and groom with family members, posing remained stiff and lifeless—no doubt a by-product of the required length of early exposures. As the style and variety of wedding photography progressed, posing techniques closely mimicked the classical arts; accordingly, there remain many flawless wedding portraits from those early years.

In today's wedding coverage, a photojournalistic approach is the state of the art. As a result, posing is not high on the priority list of the contemporary wedding photographer. This does not, however, mean that posing is absent from wedding photography. While today's top wedding photographers may not rigidly control each pose, their considerable posing input is obvious in each elegantly crafted image. Is it chance that the bride's hands are so graceful and feminine? Did luck produce the flowing S-shaped curve of the body? Was it the photographer's exceptional timing that created such a stunningly beautiful gaze in the eyes of the bride? I hardly think so. It is posing, direction, and prompting. However subtly or explicitly, the photographer is controlling the way the subject presents himself or herself, which is the essence of posing.

Rather than completely losing sight of the posing rules, the great portrait and wedding photographers of today have simply chosen to incorporate them into a less formal framework. That is to say, they haven't necessarily lost the understanding of fundamental posing, but instead have chosen to interpret those rules less rigidly. The new breed of wedding photographer has no problem "directing" a shot, as long as the results look spontaneous and are emotion-filled. Also evident is a move towards fine-art imagery, complete with the elements of abstraction, symbolism, and the finer points of design. Film-making techniques have even begun to make their way into the contemporary wedding album as the world embraces the panoramic/letterbox format as a normal view of the world.

Whether the photographer loosely poses the bride or formally does so, it is the expression and the nuances that make a great image. Here, Yervant captured his bride in full stride with the instruction given to look back at the camera.

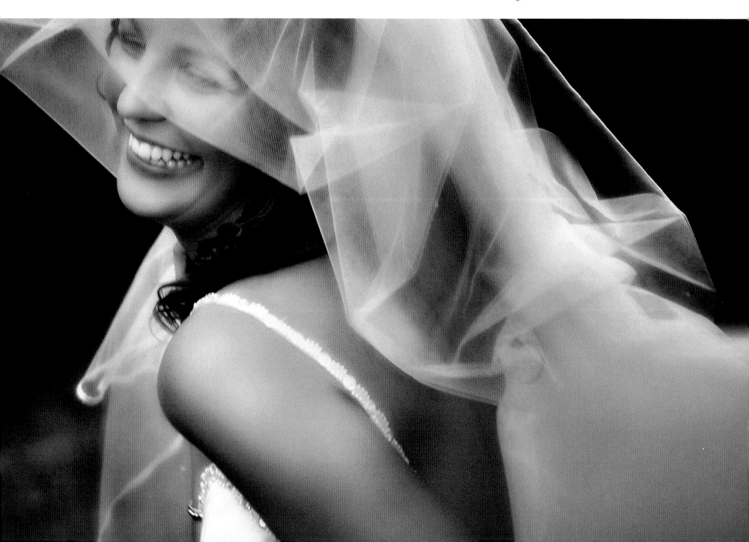

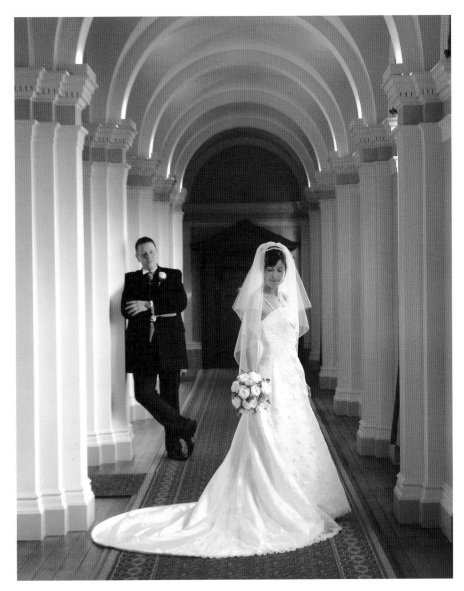

Here is a modern-day bridal portrait done in the time-honored tradition of the great wedding poses. The formal archway and splendid cross lighting add to the beautiful pose. It is reminiscent of another time, even down to the longer exposure time, which was 1/8 second at f/5.6. Photograph by David Worthington.

This free-and-easy style is exemplified by the working habits of Australian photographer Yervant Zanazanian, who is widely regarded as the foremost wedding photographer in the world. "Even though I know how to pose traditionally, I choose to break the rules, because if I pose traditionally [the couple] will be totally bored. I don't want them to be bored, I want them to interact the whole time. Put them into a position and let them come naturally into the pose," he says.

If you observe Yervant during a shoot, it's clear that his directions to subjects emphasize natural and spontaneous interactions—but they also reflect a thorough knowledge of the workings of traditional portrait posing. He knows the exact look he wants to see. His instructions, concise and delivered with the precision of a skilled film director, are full of phrases like: "You're a statue—put your arms out;" "Look at him;" "Kiss him;" "Walk toward me—you are dancing;" "Look down at your dress—follow [the line of] your shoulders;" or "Look that way and raise your chin a little."

While an organic style of posing still prevails, of late there has been a noticeable swing back toward formally posed bridals—meticulously crafted images with excellent lighting and beautiful posing. You can see the latest trends by looking at a handful of bridal magazines at the newsstand each month. The range of styles is as diverse as the types of gowns worn by today's brides.

Weddings also involve lots of groups, formal group portraits that the couple needs and wants to see in the final album. After all, a wedding is a time when families get together—and, these days, that almost never happens except at weddings and funerals. Wedding groups can range from two (the bride and groom), to ten or twelve (the wedding party), to a hundred or more (all of the assembled guests). Even if your style is that of a wedding photojournalist, groups and formals will still be a big part of what you do during the wedding day. Therefore, the accomplished wedding photographer must be adroit at photographing groups. It is a specialized genre and a discipline that

requires knowledge and practice. For this reason, this topic will be covered in detail throughout the book.

The Goal? Enduring Value.

Gifted portrait photographers have the ability to create lasting images of people that are enjoyed by generations of viewers. Much of this success is attributable to their posing skills.

Don Blair. Legendary portrait photographer Don Blair described his posing skills as an offshoot of his personality. "To me, everyone is beautiful," he said. "It's my job to bring out that beauty and capture it. This pursuit has, for me, been a lifelong obsession—an endless journey upon which I travel each working day!" In Blair's carefully crafted portraits, one sees a nearly perfect, idealized moment frozen in time in which the person's beauty and character are affectionately revealed.

David Williams. Australian David Williams summed up his approach to formal posing nicely when talking about a recent documentary portrait session. "What I have realized is that I am not making photographs just for the parents of a child. I have come to understand that we also make images for that child when he or she becomes an adult. When they look back at those images and see themselves as they were, they are looking for their parents when they were young. Such is the power and value of portraiture. Sadly, this is too often realized too late, and with much regret," he says. It's no different when a husband and wife pull out the wedding album ten years after their wedding

In a Yervant walkabout (a shoot spent wandering around taking photos with the wedding party), one is never sure what the resulting images will look like—but it will be fun, especially for the bride. Here is a bride reacting to Yervant's pleasing directions and feeling the immense joy of the moment. He treats these sessions as "important fashion shoots."

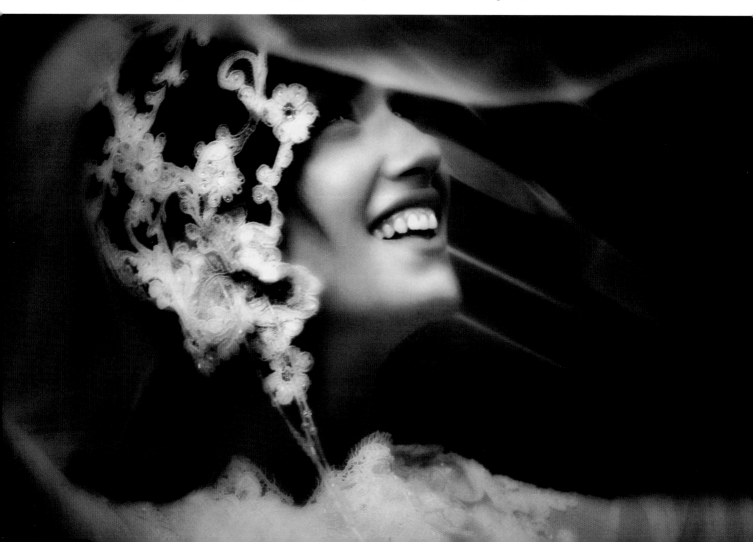

LEFT—Great wedding photographers are looking for more than perfect poses, they are looking for what Tim Kelly calls that "self-disclosing moment of self-revelation." Such is the insight Paul Wolverton uncovered in this wonderful image.

RIGHT—Martin Schembri distills his philosophy of a fine portrait down to this: "It is the essence of the person captured in a single expression." Notice the selective and careful removal of information from this image, so that in the end it is the gaze and the bride's eye that tell her story.

day and marvel at how they looked—probably better than at any other time in their adult lives.

Tim Kelly. Renowned portrait photographer Tim Kelly is someone who knows the intricacies of posing inside and out but chooses to set a different standard for fine portraiture. He looks for that fleeting moment when you may glimpse the subject in, as he calls it, "a totally self-disclosing, semi-posed moment of self-revelation." Kelly does not usually warn his clients that he is ready to begin a session. He says, "I don't believe in faking the spontaneity of the subject's expression. Every session promises something unique and unstructured." Kelly calls this style "the captured moment," not too different from the viewpoint of the wedding photojournalist, for whom spontaneity and capturing the emotion of the moment are weighed more heavily than a technically perfect pose in evaluating the overall success of an image.

Martin Schembri. Decorated Australian wedding and portrait photographer Martin Schembri uses the Mona Lisa as his benchmark of fine portraiture. "It is the essence of the person captured in a single expression," he says. While a Schembri portrait can be made classically or in a very informal style,

Off the Wall with the Sallees

A prime element of JB and DeEtte Sallee's success in the Dallas/Fort Worth area has been their ability to define something unique that only they can offer to their wedding clients. With aplomb, the Sallees have christened a new style of wedding portraiture that they call "Off the Wall, On the Wall." According to JB, "We decided to try something fun in the hopes of sparking wall portrait sales after the wedding. We prep a series of shots—some with quirky props, some in a setting special to the couple, or with a theme that reflects their personality. Coming up with themes has been fun."

The Sallees set aside roughly five minutes to create Off the Wall wedding-day shots. In these images, the posing is often irreverent and unconventional—still, the images carry with them the basics of good form, rendering the human body artistically and with acceptable perspective. "We don't want to impede on a wedding day's flow of events. We just want to nab a fun shot that will hopefully add one more sale. That image has to be something they will fall in love with and just can't live without!" JB reveals, "Today's brides and grooms just don't want standard wedding pictures or wall portraits, so this is another reason why we've had such a great reception."

LEFT—*JB and DeEtte Sallee offer their "Off the Wall" package to their couples, which often represents the antithesis of traditional posing. Here is one such image entitled* Shades of Love.

he demands that the posing of all of his portraits be comfortable and natural (to the viewer) and that the pose not appear contrived. He offers this advice about making each portrait unique: "Ensure that your portraits are as individual as each person you photograph and never treat the exercise as one in which the technicalities rule."

A Final Note
Many thanks to the wonderful photographers who contributed both their images and expertise to this book. It would not have been possible without them. Please see pages 118–22 for a complete listing of contributors.

1. A Foundation for Success

What Gene Higa enjoys most about destination weddings is integrating the local character into his pictures. This portrait was taken in Lima, Peru. Gene brought the couple to the Plaza Mayor to photograph them in front of a cathedral. Soon, however, the photo shoot became a spectacle, with curious people crowding in to watch or to offer their blessings and touch the bride. Says Gene, "It was a typical Peruvian moment, and I wanted to deliver the experience in my photograph." He included the onlookers to create a rich photograph that caught the personalities of not just the bride and groom, but the people of Lima as well. The image became one of the couple's favorites.

Make Friends

Most successful wedding photographers get to know the couple and their families before the wedding so that everyone knows what to expect. This process can involve in-studio consultations, creating an engagement portrait (in which the photographer and couple actually work together), sending handwritten notes, communicating via e-mail, and talking on the phone.

Alisha and Brook Todd, successful wedding photographers in the San Francisco area, send out a bottle of Dom Perignon and a hand-written note the day after the contract goes out, then follow it up with monthly phone calls to check in. The more familiar the couple is with the photographer, the better the pictures will be on the wedding day.

In this process of starting a relationship with your bride and groom, be sure that you are sharing something of yourself with them. This is what helps ensure that, come the day of the wedding, you will be welcomed as a friend of the couple, not just as a vendor they hired.

A thorough facial analysis will not only reveal your client's physical assets, but also the best expression to enhance those assets. Photograph by JB Sallee.

Facial Analysis

During your initial consultation with the bride and groom, it is a great idea to evaluate the faces of both, much like a doctor examines a patient for symptoms. Under flat lighting, examine the subject from straight on and gradually move to the right to examine one side of the face from an angle, then repeat on the left side. You can do this while conversing with the couple and they will never even know that you are analyzing them. Examine the face on both sides from full face to profile. In your analysis, you are looking for:

1. The most flattering angle from which to photograph the person. It will usually be at the seven-eighths or three-quarters view, as opposed to head-on or in profile (see pages 30–32 for more on this).
2. A difference in eye size. Most people's eyes are not exactly the same size, but both eyes can be made to look the same size by positioning the smaller eye closest to the lens so that natural perspective takes over and the larger eye looks normal because it is farther from the lens.
3. Changes in the face's shape and character as you move around and to the side of your subject. Watch the cheekbones become more or less prominent from different angles. High and/or pronounced cheekbones are a flattering feature in males or females. A square jaw line may be softened when viewed from one angle; a round face may appear more oval-shaped and flattering from a different angle; a slim face may seem wider and healthier when viewed from head on, and so forth.
4. The person's best expression. Through conversation, determine which expression best modifies the best angle—a smile, a half-smile, no smile, head up, head down, etc.

Evaluate the faces of the bride and groom, much like a doctor examines a patient for symptoms.

5. Determine the quality of the couple's skin, particularly the bride's. Determine if diffusion will be something that will be called for in some, most, or all instances.

6. Look for their best features. Watch how they smile and take mental notes of their faces when they are listening or talking to one another.

In chapter 3, we'll look in more detail and common appearance flaws and how to correct them. This process starts, however, with observing the issues. After the meeting is over, jot down the notes of your observations and throw them in the couple's file. You will soon have a chance to test your theories and observations.

Get to Know the Event

Preparation is critical when photographing a once-in-a-lifetime event that is as complicated as a wedding. With lots of people, places, and events to document, getting all the details and formulating a plan will help ensure you're ready to capture every moment.

Begin by arranging a meeting with the couple at least one month before the wedding. Use this time to get all the details, formulate detailed plans, and get to know the couple in a relaxed setting. Make notes on the color scheme, the supplier of the flowers, the caterer, the band, and so on.

Cars and weddings have gone together since the 1950s. In this Brett Florens shot, a 1960 Chevy almost steals the show from the bride and groom. Brett often uses a two-million candle-power flashlight to fill the shadows of dusk or even night scenes.

ABOVE—Emin Kuliyev of New York City, uses ultra-fast lenses like the Canon EF 85mm f/1.4L to shoot wide open. On a New York street in mid-afternoon, the light was subdued by the skyscrapers, but Emin was able to shoot at $\frac{1}{500}$ second at f/1.6, blowing out the background into a mosaic of pastels. No posing was needed—only the photographer's fast reflexes!

RIGHT—It is important to make a special portrait of the groom before the ceremony. This one is by Marcus Bell.

After the meeting, contact all of the vendors just to touch base. You may find out interesting details that will affect your timetable or how you make certain photos. Introduce yourself to the people at the various venues (including the minister, priest, or rabbi), and go back to the couple if there are any problems or if you have questions.

If you have not worked at the couples' venues before, try to visit them at the same times of day as the wedding and reception. That way, you can check the lighting, make notes of special locations, and catalog any potential problems. Also, you should make note of the walls and types of ceilings, particularly at the reception. This will affect your use of bounce flash. It is useful to produce an "A" list and a "B" list of locations. On the "A" list, note the best possible spots for your images; on the "B" list, select alternate locations in case your "A" locations don't work out on the wedding day.

Perhaps the best way to get to know your clients is to offer an engagement session . . .

Your initial meeting with the couple also gives them a chance to ask any questions of you that they may have. Discuss what you plan to photograph, and show them examples. Be sure to ask if they have any special requests or special guests who may be coming from far away—but avoid creating a list of "required" photographs; it may not be possible to adhere to one.

Do an Engagement Portrait

Perhaps the best way to get to know your clients is to offer an engagement session as part of your wedding coverage (most photographers offer this session at no charge, because it affords them two to three hours of bonding time

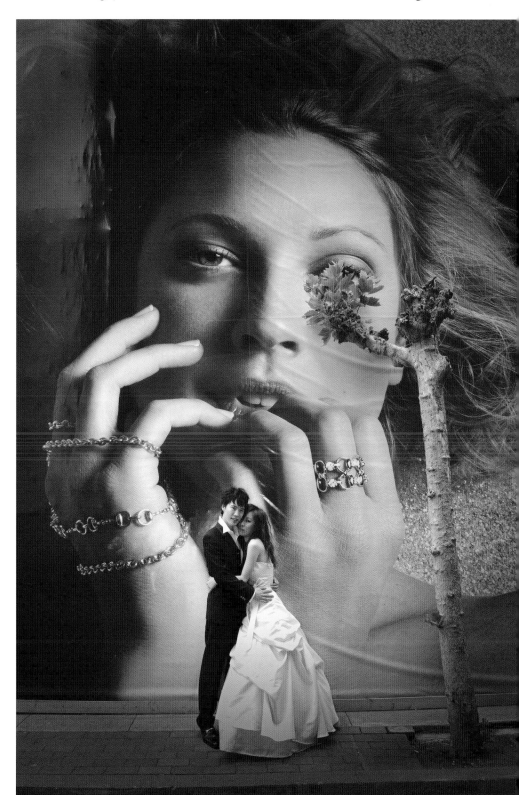

Cherie Steinberg Coté is always on the lookout for cool locations in and around L.A. to make engagement portraits. Here she found a giant-size street billboard to use as a backdrop for this young couple's engagement portrait.

with the couple). This session is usually conducted prior to the wedding, when everyone is relaxed and there's plenty of time to get something spectacular. This also allows the portrait to be used in newspapers and local magazines to announce the couple's wedding day.

Engagement portraits may involve great creativity and intimacy and may be made in the photographer's studio or at some location that is special to the couple. The session may even include multiple locations, providing great variety. Usually the couple is dressed casually for these shots, and often the poses are romantic in nature. Many photographers use these images to create a separate engagement album that the couple can purchase in addition to the wedding album.

The engagement session is a good time to test your theories, based on observation, about what poses and expressions will most flatter your subjects. If you observed that the bride tends to lapse into a half-smile that may or not be attractive, make a few frames of her in that expression and evaluate. You may find the solution as you are working and it may be as simple as saying something like, "You have a lovely smile, you should show it more often." Such flattery will, of course, encourage the bride to smile in a full manner more often.

LEFT—Some of your best full-length shots of the bride and groom may not be posed at all but taken on the run, like this one by Mike Colón.

RIGHT—JB and DeEtte Sallee offer a quirky little engagement session prior to the wedding. Here, the couple were Karaoke devotees and wanted that side of their relationship recorded in their portrait.

Make a Bridal Portrait, Too

According to Kevin Jairaj, doing a bridal session before the wedding is a great idea (and very profitable too!). It allows him to get to know the bride a lot better and to see what she is comfortable with in regard to her photos. It is also a great dress rehearsal for the bride as she can make sure that all parts of her dress fit just right and look exactly the way she wants.

Kevin always approaches his bridal sessions with the attitude that it's more like a fashion shoot. He tells his brides to "expect to be my model for a day and to prepare to have a lot of fun." During the session, he will do quite a variety of shots from very sexy and fashion-forward, to a few traditional ones to please Mom and Grandma. He offers some tips:

1. Tell the bride to have a glass of wine to relax before the session, as putting on the wedding dress comes with a few nerves.
2. Have the bride wear comfortable shoes (tennis shoes or flip flops) especially if you cannot see her shoes under her dress when she is standing. Having your bride get blisters while walking around in her heels is no way to have a productive shoot! For any shots sitting down you can simply have her put her heels on when you get to the spot.
3. Bring a white sheet or clean painter's plastic to place under the dress during some shots. This is the secret to not getting the dress dirty. Some brides are terrified to have their $10,000 dress get dirty before the wedding! Have her sit on the sheet or the plastic and then tuck it under her dress so that it doesn't show.
4. Have her bring friends to the session to help out with all the stuff (shoes, makeup, tissues, etc.). "Most brides seem to relax more when their friends are around," Kevin notes.

Kevin tries to do the bridal session about two months before the actual wedding, since the bride's weight, hair length, etc. will be pretty close to what it will be on the wedding day. Also, that allows him plenty of time to order and frame a print to be displayed at the reception. A typical bridal session will last about two to three hours.

Have a Master Schedule

Planning is essential to a smooth wedding day. The couple should know that if there are delays, adjustments or deletions will have to be made to the requested pictures. Good planning and an understanding of exactly what the bride and groom want will help prevent any problems.

Inform the bride that you will arrive at the her home or hotel room (or wherever she is getting ready) at least 45 minutes to an hour before she leaves for the church. You should know how long it takes to drive from there to the ceremony, and leave in time to arrive at church at about the same time as (or

An understanding of exactly what the bride and groom want will help prevent any problems.

a little before) the groom, who should arrive about a half-hour before the ceremony. At that time you can make portraits of the groom and his groomsmen and his best man while you wait for the bride and bridesmaids to arrive. (For more on photographs to take before the wedding, see pages 91–92.)

If the ceremony is to take place at a church or synagogue where you do not know the customs, make sure you visit the officiant beforehand. If you are unfamiliar with the customs, ask to attend another wedding as an observer. Such experiences will give you invaluable insight into how you will photograph the wedding.

Bear in mind that having a master schedule does not preclude massive scheduling changes. A good plan will only guarantee that you are prepared for the events as they are planned, not necessarily how they will actually unfold. Yet, the better your preparation and planning, the more adept you and your team will be at making last-minute adjustments.

Learn Everybody's Names

Photography is not just about the images, it also involves people skills. Photographer Frank Frost believes that you should master the names of the key players. He says, "There can be twenty people in the wedding party and I'm able to call everybody by name. It makes a big impression and, by the end of the evening, everybody is my friend." At the very least, you should make a note of the parents' names, as well as the names of the bridesmaids, groomsmen, the best man, and maid of honor, so that you can address each one. If you are not good at memorizing names, you must practice.

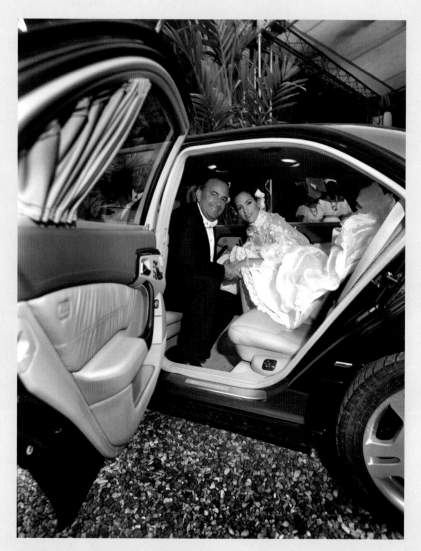

Getting the Bride Into the Car

This tip is from the late Monte Zucker, who says, "I learned a long time ago how to help the bride sit in a car without wrinkling her gown. I have her lift up the back of her gown and put it around her shoulders. This forms a sort of cape. It also picks up the back of the gown, so that when the bride sits down she's not sitting on her dress and wrinkling it. Here's the final trick. She has to back into the car. Now, even if she were to pick up some dirt as she enters, it would be on the underside and never show."

ABOVE—*You can see by the way this bride has gotten into the limo that she knew how to do it without soiling or wrinkling the gown. Photograph by Mauricio Donelli.*

Here, the air of formality matches the opulent surroundings. The bride is at an angle to the camera, while the groom is more straight on to the camera, providing a solid base to the portrait. Both left hands are left to fall straight down; this is not usually a good idea, but in this case it shows off their rings. The background has been selectively softened to take the emphasis off of its many details. It is always a good idea to pose the bride in front of the groom so that you can show off the wedding dress. Photograph by Joe Photo.

Work with an Assistant

An assistant is invaluable at the wedding. He or she can run interference for you, change or download CompactFlash (CF) cards, organize guests for a group shot, help you by taking flash readings and predetermining exposure, tape light stands and cords securely with duct tape, and tackle a thousand other chores. Your assistant can survey your backgrounds looking for unwanted elements—and even become a moveable light stand by holding your secondary flash or reflectors.

To function effectively, your assistant must be trained in your posing and lighting techniques. The wedding day is not the time to find out that the assistant either doesn't understand or—worse yet, *approve of*—your techniques. You should both be on the same page; a good assistant will be able to anticipate your next need and keep you on track for upcoming shots.

Most assistants go on to become full-fledged wedding photographers. After you have developed confidence in an assistant, he or she can help with the photography, particularly at the reception, when there are too many things going on at once for one person to cover. Most assistants try to work for several different wedding photographers to broaden their experience. It's not a bad idea to employ more than one assistant so that if you get a really big job you can use both of them—or if one is unavailable, you have a backup assistant.

Assistants also make good security guards. I have heard many stories of gear "disappearing" at weddings. An assistant is another set of eyes who can make it a priority to safeguard the equipment.

Dress for Success

Photographer Ken Sklute says it's important to select your wedding-day attire carefully. A suit or slacks and a sports jacket are fine for men. For women, business attire works well. Remember that you have to lug equipment and move freely, though, so don't wear restrictive clothing. Many wedding photographers (men *and* women) wear a tux for formal weddings.

2. Posing Basics

In any discussion of subject posing, the two most important elements to keep in mind are that the pose appear natural (*i.e.*, that the subject does not look posed), and that the person's features be undistorted. If the pose is natural and the features are rendered normally, in proper perspective, then you

LEFT—Today's tools allow the photographer to work unimpeded from the shadows so that moments like this do not go unrecorded. Photograph by Jeff and Julia Woods.

ABOVE—Joe Photo created this very casual portrait of the groom sitting on a sofa prior to the big day's events. Men traditionally sit with their knees apart, which is okay for this decidedly masculine portrait.

In this portrait, Michael O'Neill had the bride lean forward, making her slim and muscular arms become a big part of the composition. It's a very effective pose with an athletic bride.

will have achieved a major goal, and the portrait will generally be considered aesthetically pleasing to both the photographer and the subject. To be certain, there is much more that goes into a great portrait than adequate posing, but without these elements, the more artistic elements would not be appreciated or even noticed.

While every rule of posing could not possibly be followed in every portrait, the rules do exist for a purpose. In short, they provide a framework for achieving the aforementioned goals: portraying the human form naturally, flatteringly, and without distortion.

Additionally, it should also be noted that there is a great deal of difference between the time a studio portrait photographer has to spend with the subject and the time a wedding photographer has to spend with the bride and groom on their wedding day. For this reason, wedding photographers must be all the more versed in posing skills—so that slight but important adjustments can be made quickly in the midst of the chaotic wedding day.

Start with the Feet and Legs

Standing Poses. The basic rule of thumb is that no one should be standing at attention with both feet together—or, worse yet, with their weight on their front foot. Instead, the shoulders should be at a slight angle to the camera and the front foot brought forward slightly.

The subject's weight should then be put on the back foot. This has the effect of creating a bend in the front knee and dropping the rear shoulder to a position lower than the forward one. This helps break up the static line of a straight leg. When used in full-length bridal portraits, a bent forward knee will lend an elegant shape to the wedding dress. With one statement, "Weight on your back foot, please," you can introduce a series of dynamic lines into an otherwise average composition.

With the weight on the back foot, the posture improves, producing an elegant line down the back and shoulders of the bride. Notice how lifting her hands to her waist, holding the bouquet, causes her elbows to extend out from her torso, creating an open space that visually slims the arms. It also provides a triangular base to the composition. Notice thay the photographer had the bride raise her chin slightly, elongating the graceful line of her neck. Photograph by Joe Photo.

> Seated subjects should sit forward in the chair, which should be angled to the camera.

In both standing and seated poses, you should have the subject's feet positioned at an angle to the camera. Feet tend to look stumpy, large and very unattractive when photographed straight on.

Seated Poses. Seated subjects, especially women, should sit forward in the chair, which should be angled to the camera. The weight should be moved forward to slim the lines of her legs and thighs. Her weight should be transferred to the far leg (the one away from the camera), thus slimming the leg

and thigh most visible to the camera. Also, keep a slight space between the leg and the chair as much as possible; this will slim thighs and calves.

If a cross-legged pose is desired, position the top leg at an angle to the camera and not square to the lens. With a seated woman, it is a good idea to have her tuck the calf of the front leg in behind the back leg. This reduces the size of the calves, since the back leg, which is farther from the camera, becomes the most important visually. This is a pose women fall into somewhat naturally. When photographing men in cross-legged poses, be sure their socks are pulled up high enough so that you don't see any bare leg.

The Torso

Turning the plane of the body—the torso and hips—so that is at an angle to the camera will produce a more dynamic effect and enhance the various curves and planes of the body. Turning the body plane *away* from the main light source will help to maximize body definition and enhance the detail in clothing, like the subtle beadwork of a bride's wedding dress. Turning the subject's body plane toward the light source may wash out or flatten important detail in both the form of the body and the texture of the clothing.

Additionally, good posture is essential to an effectively rendered body plane. You must be conscious of the subject slouching and be prepared to improve the subject's pose by coaching or subtle actions like placing a hand on the small of the subject's back. This will automatically cause the spine to stretch and elongate.

In Seated Poses. Don't allow seated subjects to lean back into the chair, placing their lower back in contact with the chair back. This thickens the person, especially in the torso. Instead have them move forward toward the front edge of the seat and sit with good posture and a slight bend forward at the waist.

> Good posture is essential to an effectively rendered body plane.

Marcus Bell often seats the bride for an informal portrait when she's finished getting ready. Notice that he has her sit on the edge of the sofa with her back arched for good posture. Her hands are hidden behind her bouquet and she is positioned at a 30-degree angle to the camera to take good advantage of the split lighting.

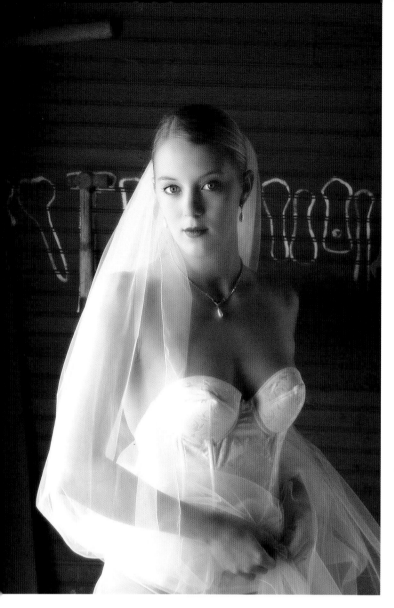

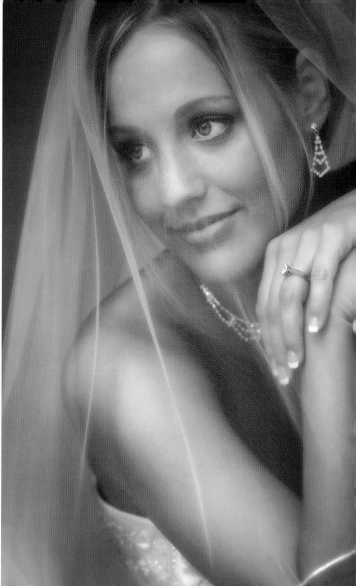

When a man is seated for a portrait, his tuxedo jacket or suit coat should be unbuttoned to prevent it from looking too tight across the torso. Also, he should not be sitting on the bottom of the coat, pulling it up in the front. His shirt cuffs should be pulled down in the jacket arms in order to be visible.

The Shoulders

The subject's shoulders should be turned so that they are at an angle to the camera. When the shoulders face the camera straight on, it makes people look wider than they really are. It can also create a static composition. (*Note:* This rule is sometimes broken with very thin subjects or when a very assertive look is desired, as in fashion portraiture.)

Additionally, one of the subject's shoulders should normally be at least a little higher than the other (*i.e.,* not parallel to the ground). This can be achieved in a number of ways. For instance, in a standing portrait, instructing the subject to place his or her weight on their back foot will create a gently sloping shoulder line. In a seated head-and-shoulders portrait, having the

LEFT—When the hands are raised to waist level and the elbows extended, it produces a triangular base for the composition. Notice that the head and neck axis are ideal in this John Poppleton portrait.

RIGHT—The beautiful line of the shoulders defines the composition of this bridal portrait. The shoulders produce a 45-degree angle, which is followed by the line of the head to produce a very elegant portrait. Photograph by JB Sallee.

Joints

Never frame the portrait so that a joint—an elbow, knee, or ankle, for example—is cut off at the edge of the frame. This sometimes happens when a portrait is cropped. Instead, crop between joints, at mid-thigh or mid-calf, for example. When you break the composition at a joint, it produces a disquieting feeling.

Photographer Michael O'Neill does a masterful job of separating the bride's arms from her torso by using a second chair as a posing prop. Separating the arms from the body slims the figure and makes the pose and composition more elegant.

subject lean forward from the waist will create sloping line through the shoulders (provided the person is at an angle to the camera, as noted above). This tilt of the shoulders introduces a dynamic line into the composition.

The Arms

The subject's arms, regardless of how much of the subject is showing in the portrait, should not be allowed to fall to their sides. Instead, they should project outward to provide gently sloping lines and a triangular base for the composition, which attracts the viewer's eye upward, toward the subject's face.

This is commonly achieved by asking the subject to separate their arms from their torso by creating a bend in the elbows. In a seated portrait, what normally happens is that the subject will move his or her joined hands closer to the waist, producing slightly projecting elbows. In a standing portrait, men can place their hands in their pockets to produce the triangular base; a bride can bring her bouquet up to her waistline to produce the same effect.

This pose also creates a slight space between the upper arms and torso. This helps slim the appearance of both the arms and the torso, which can look wider than it is when the arms lay flat against it.

The Hands

Posing the hands properly can be very difficult, because in most portraits they are closer to the camera than the subject's head. Thus, they appear larger.

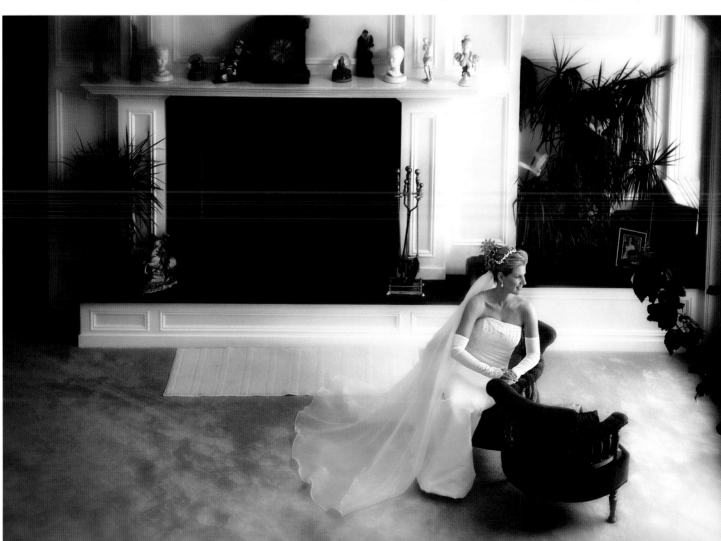

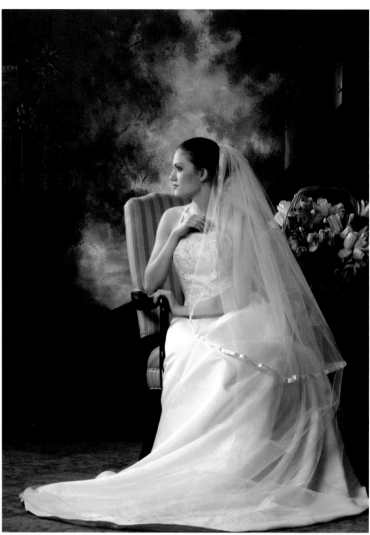

One thing that will give hands a more natural perspective is to use a longer lens than normal. Although holding the focus of both hands and face is more difficult with a longer lens, the size relationship between them will appear more natural. Additionally, if the hands are slightly out of focus, it is not as crucial as when the eyes or face are soft.

Basic Principles. Throughout this book you'll see great examples of hand posing, pleasing images that render the hands with good dimension and form while revealing the personality of the subject. It is impossible here to cover every possible hand pose, so it is necessary to make a few generalizations (and keep in mind that these are just that—generalizations, not hard and fast rules):

1. Avoid photographing a subject's hands pointing straight into the camera lens. This distorts the size and shape of the hands. Instead, keep the hands at an angle to the lens.
2. Photograph the outer edge of the hand when possible. This gives a natural, flowing line to the hands and eliminates the distortion that occurs when hands are photographed from the top or head-on.

LEFT—A beautiful portrait of the bride with her bouquet is essential. This image, made in the ultra-soft light of a portico, displays the wild colors of her bouquet. Photograph by Noel Del Pilar.

RIGHT—This is an elegant formal studio portrait done by Rick Ferro. Notice that the bride's hands are treated delicately. Rick made sure to photograph the edges of the hands and extend the fingers to give the hands length and grace. Notice, too, the gentle bend of the wrist in each hand.

3. Bend the wrist slightly so there is a gently curving line where the wrist and hand join.

4. Photograph the fingers with a slight separation in between them. This gives the fingers form and definition. When the fingers are closed together, they appear two-dimensional.

Women's Hands. When posing women's hands, you should generally strive to create a sense of grace. Obviously, the type of portrait and the subject must also be considered. For example, the hands of a female soldier in uniform would more logically be posed to convey strength than delicate grace.

In wedding portraits, posing women's hands often involves working with a standing subject holding a bouquet. When doing this, it's important to make sure the woman, whether the bride or one of her bridesmaids, looks comfortable holding the flowers. Ask her to place the bouquet in front of her body with her hands behind it. Make sure she holds it high enough to put a slight bend in her elbows, keeping her arms slightly separated from her body. Getting this hand pose just right is especially important in the the formal portraits of the bride.

With a standing woman who is not holding a bouquet, placing one hand on a hip and the other at her side is a good standard pose. Don't let the free hand dangle, though; have her turn the hand so that the edge shows to the camera. Always create a break in the wrist for a more dynamic line.

Men's Hands. In general, a man's hands should be posed to show strength. When photographing a man's closed hand, give him something

Here are several variations for men and women. Notice that women's hands have grace and men's hands have strength. Some similarities between the posing are that the edge of the hand is photographed more often. The fingers are often separated so they do not appear to be one single unit. The break of the wrist is gentle, rather than abrupt.

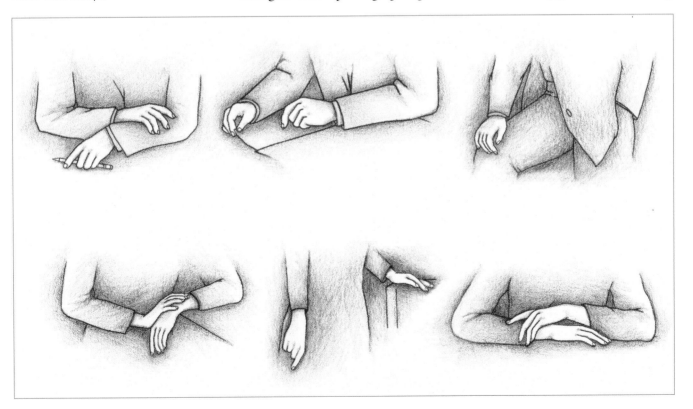

small, like the cap of a pen, to wrap his fingers around. This gives roundness and dimension to the hand so that it doesn't resemble a clenched fist.

When photographing a man in a standing pose, folding his arms across his chest produces a good, strong look. Remember, however, to have the man turn his hands slightly, so the edge of the hand is more prominent than the top of the hand. In such a pose, have him lightly grasp his biceps—but not too hard or it will look like he's cold. Also, remember to instruct the man to bring his folded arms out from his body a little bit. This slims down the arms, which would otherwise be flattened against his body, making them (and him) appear larger. Separate the fingers slightly.

Three Views of the Face

There are three basic head positions in portraiture: the seven-eighths, three-quarters, and profile views. With all three of these head poses, the shoulders should be at an angle to the camera, as noted above.

Seven-Eighths View. The seven-eighths view occurs when the subject is looking just slightly away from the camera. In other words, you will see just a little more of one side of the face than the other when looking through the camera. You will still see both of the subject's ears in a seven-eighths view; one just slightly more than the other. This is the best approach to use even when creating a head-on view, because the very slight turn of the face will help ensure that you avoid the dreaded "mug-shot" look.

Three-Quarters View. In the three-quarters view (sometimes called the two-thirds view), the far ear is hidden from the camera and more of one side of the face is visible. With this type of pose, the far eye will appear smaller because it is farther away from the camera than the near eye. Therefore, it is important when posing the sitter in a three-quarters view to position him or her so that the smaller eye (people generally have one eye that is slightly smaller than the other) is closest to the camera. This way, the perspective is used to make both eyes appear to be the same size in the photograph. When creating this view of the face, it is important that the eye on the far side of the face be contained within the facial area. This is accomplished by ensuring that a small strip of skin along the far temple is visible in the portrait.

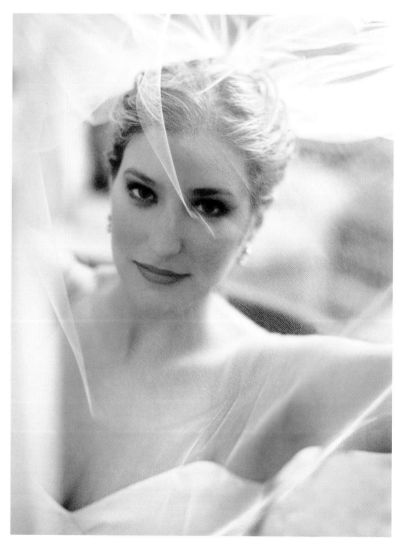

As seen here, the seven-eighths view is almost a straight-on view of the subject. Photograph by Jose Villa.

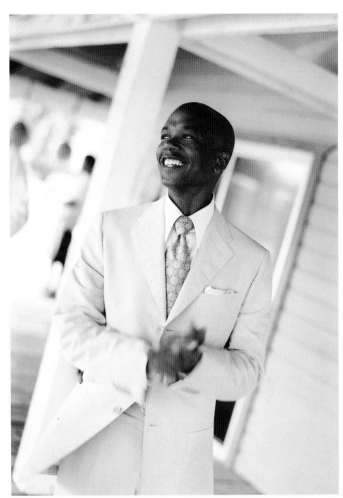

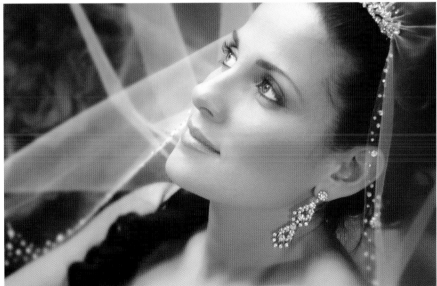

TOP LEFT—The three-quarters view is the most widely used facial pose. Photograph by Marc Weisberg.

TOP RIGHT—The three-quarters view is nearing the profile pose, but not quite. It exposes most of the one side of the face, but both eyes are visible. Photograph by Jose Villa.

RIGHT—Although this bride is flawless in her appearance, everyone has one eye smaller or larger than the other. Positioning the small eye closest to the camera allows natural perspective to correct the size differential between the eyes. Photograph by Michael O'Neill.

Profile View. In the profile, the head is turned almost 90 degrees to the camera. Only one eye is visible. When posing your subject in a profile position, have him or her turn their head gradually away from the camera position until the far eye and eyelashes just barely disappear from camera view. If

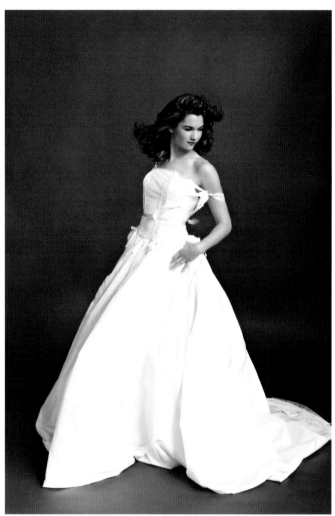

you cannot see the eyelashes of the far eye, then you have a good starting point for a profile pose.

Head Tilt

Each subject's head should be at least slightly tilted (for a natural look, this should not be overly exaggerated). By doing this, you slant the natural line of the person's eyes. When the face is not tilted, the implied line is straight and parallel to the bottom edge of the photograph, leading to a static feeling. By tilting the person's face to the right or left, the implied line becomes diagonal, making the pose more dynamic.

With men, the head is more often tipped in the same direction as the far shoulder (*i.e.*, tilted toward the lower shoulder), but not necessarily to the same degree. With women, the head is often at a slightly different and opposing angle (*i.e.*, tilted toward the higher or near shoulder). While this is often regarded as a cliché, like most clichés it exists for a reason. The "masculine" tilt of the head provides an impression of strength, a traditional male characteristic; the "feminine" tilt creates an impression of mystery and vulnerability, characteristically female traits. This "rule" is frequently disregarded,

LEFT—The profile pose is unique and not used that often. It takes an elegant bone structure and a disciplined pose to pull it off effectively. Photograph by Yervant.

RIGHT—The head and shoulders axes create dynamic lines within the composition. This beautiful studio formal by Marc Weisberg features basic "feminine" posing, where the bride's head is tilted toward her higher shoulder.

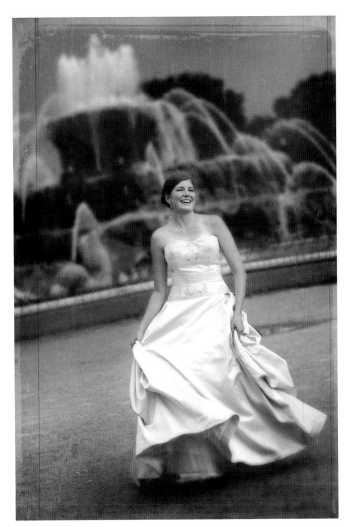

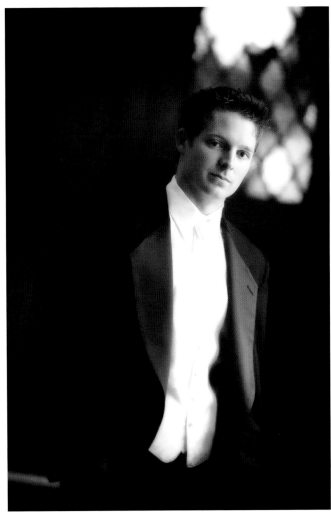

LEFT—Even though the shoulders are basically square to the camera, the head tilt, with the bride throwing her head back in laughter, makes this striding portrait come to life. Photograph by Parker Pfister.

RIGHT—This is a fine example of the classic "masculine" posing, where the man tilts his head toward his lower shoulder. Note that his shoulders are also turned to a different angle than his face. Photograph by Jeff and Julia Woods.

because the lighting used will usually determine what best flatters the subject, but the strategy is mentioned here so that you can decide for yourself.

The Eyes

The area of primary visual interest in the human face is the eyes. The wedding photographer must live by the notion that the eyes are the most expressive part of the face. If the subject is bored, tired, or uncomfortable, you will see it in his or her eyes.

The best way to keep your subject's eyes active and alive is to engage them in conversation. Try a variety of conversational topics until you find one he or she warms to and then pursue it (this should be relatively easy if you've already conducted an engagement session with the couple). By holding their interest, you will take the subject's mind off of the photograph.

Another way to enliven your subject's eyes is to tell an amusing story. If they enjoy it, their eyes will smile—one of the most endearing expressions a human being can make. You may also want to mount your camera on a tripod and shoot with a cable release; this forces you to become the host and allows you to physically hold the subject's gaze.

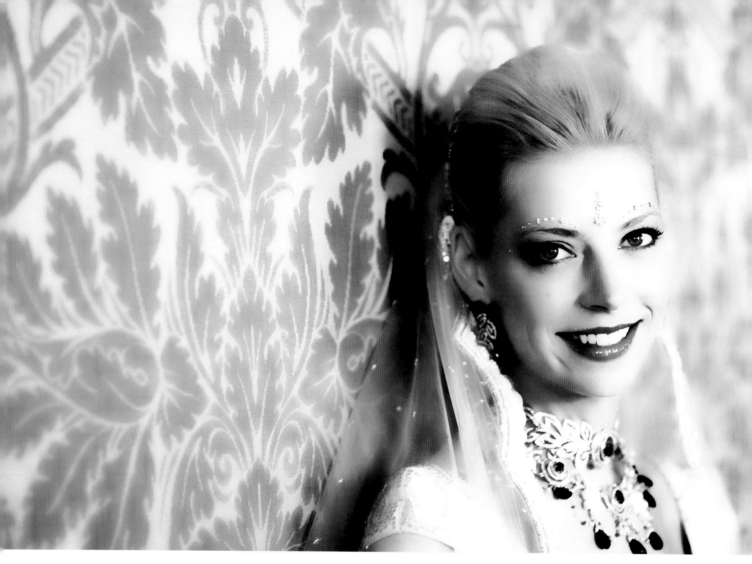

When optimally positioned, the colored part of the eye, the iris, should border the eyelids. In other words, there should not be a white space between the top or bottom of the iris and the eyelid. If there is a space, have the subject lower his gaze.

Pupil size is also important. If working in bright light, the pupil will be very small and the subject will look beady-eyed. A way to correct this is to have them shut their eyes for a moment prior to exposure. This allows the pupil to return to a normal size for the exposure. Just the opposite can happen if you are working in subdued light. The pupil will appear too large, giving the subject a vacant look. In that case, have the subject stare momentarily at the brightest nearby light source to close the pupil.

The line of the eyes should normally be at least slightly tilted (i.e., not parallel with the bottom of the image). This is accomplished by having the subject tilt their head.

The eyes are the most important part of a portrait. Note that, here, the eyes are at a slight slant to produce a good set of dynamic lines within the portrait. The photographer, Joe Photo, keeps the bride engaged with conversation.

Chin Height

Be aware of the effects of too high or too low a chin height. If the chin is too high, the subject may look "snooty." If the chin height is too low, the neck

will look compressed, or worse, like the person has no neck at all. The subject may also look depressed. A medium chin height is usually the best choice.

The Mouth

A subject's mouth is nearly as expressive as their eyes. Pay close attention to the mouth to be sure there is no tension in the muscles around it, since this will give the portrait an unnatural, posed look. Again, an air of relaxation best relieves tension, so talk to the person to take his mind off the session.

Expression. It is a good idea to shoot a variety of expressions, some smiling and some serious—or at least not smiling. People are often self-conscious

> Pay close attention to the mouth to be sure there is no tension in the muscles around it.

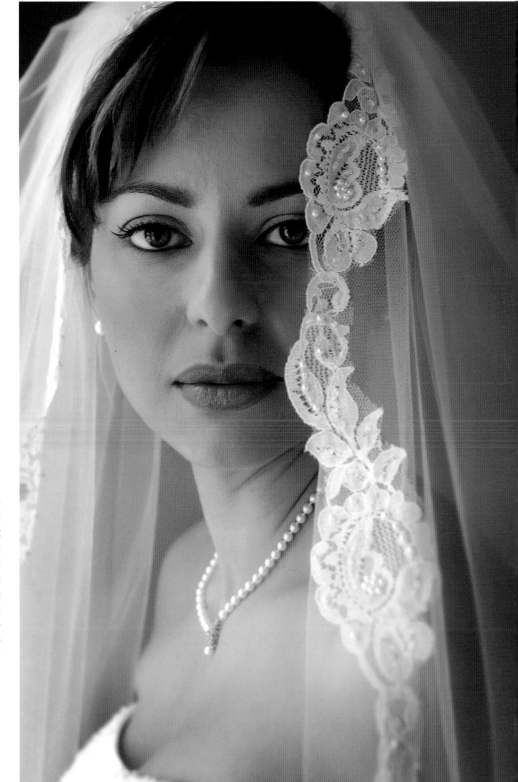

The photographer wanted to exploit the exceptional beauty of this bride's eyes and mouth. Notice that the pose is pleasant but not smiling. The line of the eyes forms a straight line, which is usually not a good idea because it creates a static line in the composition. Here, however, the eyes are the focal point of the composition and their perfect shape and subtle olive coloring are emphasized by the pose. Photograph by Michael O'Neill.

about their teeth and mouths, but if you see that the subject has an attractive smile, get plenty of shots of it.

One of the best ways to produce a natural smile is to praise your subject. Tell them how good they look and be positive. Simply saying, "Smile!" will produce a lifeless "Say cheese!" type of portrait. With sincere flattery, however, you will get the person to smile naturally and sincerely and their eyes will be engaged.

One of the best photographers I've ever seen at "enlivening" total strangers is Ken Sklute. I've looked at literally hundreds of his wedding images and in almost every photograph, the people look happy and relaxed in a natural, typical way. Nothing ever seems posed in his photography—it's al-

If you observe this, gently ask them to bring their lips together.

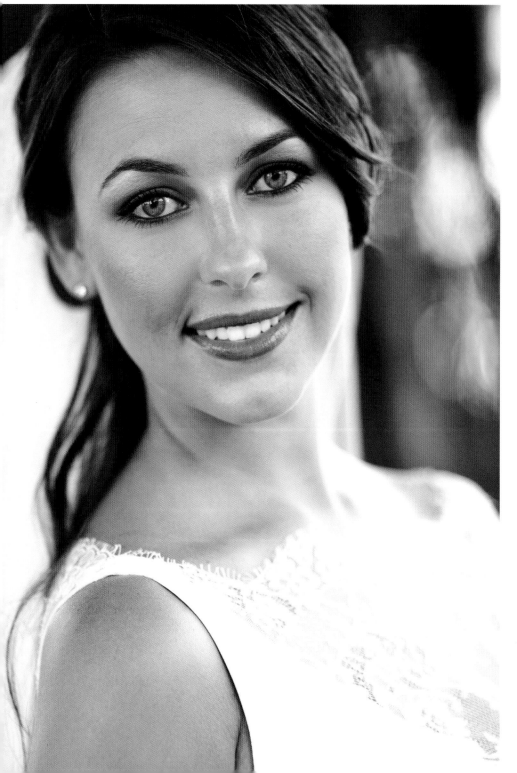

A bride's smile should be natural and beautiful, not forced. When everything is working, you get a beautiful expression like this. Sometimes, how realistic and natural the smile appears is a function of the photographer's interaction with the subject. Photograph by Gordon Nash.

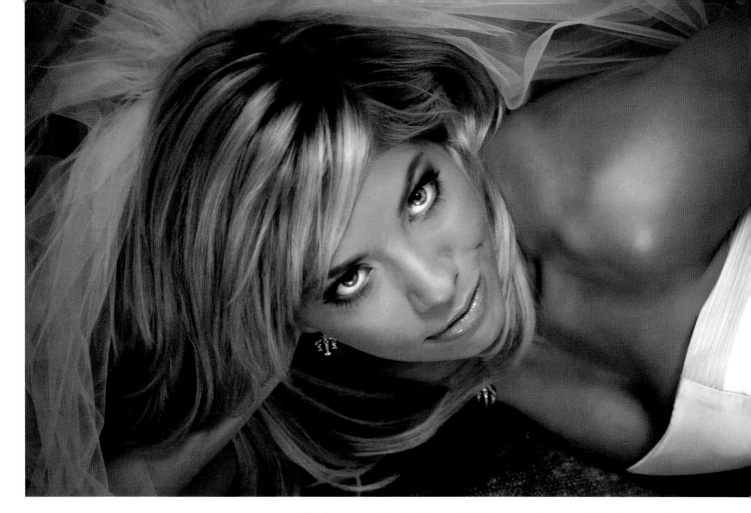

If you bring a bride to your studio for a formal portrait, it is a good idea to have a makeup artist on hand. Here, the bride's makeup is flawlessly applied and her hair is done perfectly. Combined with a subtle but effective retouching effort, this is a first-class bridal portrait. Photograph by Cherie Steinberg Coté.

most as if he happened by this beautiful picture and snapped the shutter. One of the ways he gets people "under his spell" is his enthusiasm for them and for the excitement of the day. His enthusiasm is contagious and his affability translates into attentive subjects. While it helps any wedding photographer to be able to relate well to people, those with special gifts should use them to get the most from their clients.

Lips. It will be necessary to remind the subject to moisten his or her lips periodically. This makes the lips sparkle in the finished image, as the moisture produces tiny specular highlights on the lips. Some people also have a slight gap between their lips when they are relaxed. If you observe this, gently ask them to bring their lips together. While this trait is not something you'd even notice in most cases, a gap between the lips will look unnatural in the subject's portrait because of the teeth showing through it.

Laugh Lines. An area of the face where problems occasionally arise is the frontal-most part of the cheeks—the parts of the face that crease when a person smiles. Some people have pronounced furrows, or laugh lines, which look unnaturally deep when they are photographed smiling. You should take note of this area of the face. If necessary, you may have to increase the fill-light intensity to fill in these deep shadows, or adjust your main light to be more frontal in nature. If the lines are severe, avoid a "big smile" type of pose altogether.

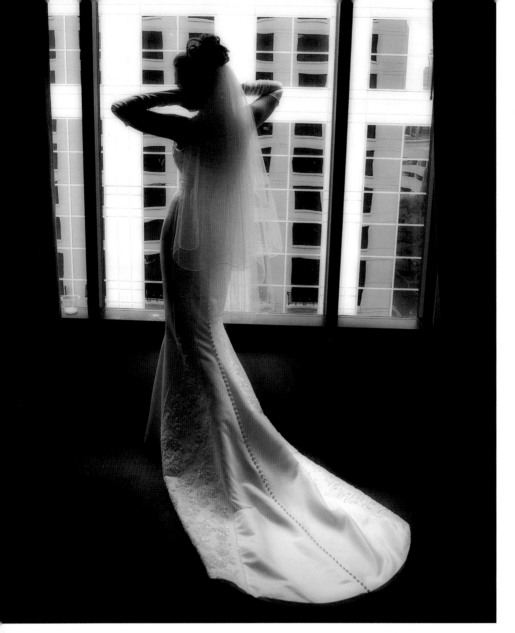

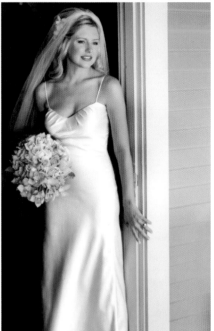

ABOVE—A bride's hair and makeup will usually be flawless on the wedding day. It is the photographer's job to make the lighting and pose work together to further optimize her appearance. Photograph by Gordon Nash.

LEFT—This shot by Jeff Hawkins was created expressly to show off the beautiful train of the bridal gown. Jeff used window light and had the bride extend her left leg in order to create a fuller line to the train. He allowed the bride's torso to fall into shadow, using the window light to fully illuminate the train.

The Nose

The shape and size of a person's nose can be modified in portraiture if the photographer is aware of what needs to be corrected. The most obvious thing *not* to do is photograph a long or large nose in profile. Long noses can be shortened by photographing from below; conversely, a short or pug nose will be lengthened by using a higher camera angle. Crooked noses should be photographed with the subject in a three-quarter view, so the crookedness is not visible from the camera position. Another method of dealing with a longish nose is to use a longer lens, which compresses facial features. Especially in the seven-eighths or three-quarters view, a long nose can be made to look more natural by using a telephoto.

Styling and Posing Work Together

Makeup. Professional hairstyling and makeup are essential to an elegant wedding portrait, but the stylists should be familiar with what works photo-

graphically. With makeup, a little goes a long way, since the photographic process increases the contrast of the scene. Eye makeup should be blended with no sharp demarcation lines between colors. Foundation should be blended carefully over the jaw line and onto the neck, avoiding an abrupt color change between the face and neck. Mascara is almost essential—even women who don't usually want makeup should be photographed with mascara. A gloss lipstick is also important, as is eye shadow that defines the eyes but does not call attention to the color of the eyelids.

Hairstyle. Hairstyles should be made to endure a number of climactic changes—outdoor sun with breeze, indoors with air conditioning, etc. The hair should not look frozen with hair spray, but should have a certain "give" and bounce. However, the hairstyle should not fall apart the minute the bride walks out into a breeze. Usually the veil helps control the look.

The Train. Formal wedding dresses often include flowing trains. It is important to get several full-length portraits of the full train, draped out in front of the bride in a circular fashion or flowing out behind her. Include all of the train, as these may be the only photographs of the bride's full wedding gown. To make the train look natural, position it as desired, then pick it up and let it gently fall to the ground.

Stairs are excellent for displaying the full train because they allow it to flow down naturally. Full-length seated portraits are also popular. In these, the train can be draped out in front of the bride at an angle. (*Note:* If you decide to make a full-length seated portrait, zoom in and make a few close-ups of the same pose. These can be used for newspaper announcements of the wedding.)

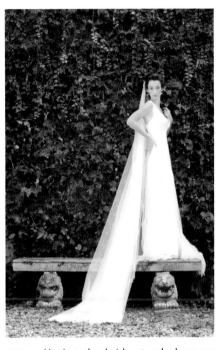

ABOVE—Having the bride stand alone on the stone bench shows off the train almost better than had it been trailing behind her as she walked up the aisle. This view shows the length and shape of the train as well as providing a beautiful full-length view of the bride. Photo by Brett Florens.

RIGHT—Beautiful through-the-veil shots are almost a requirement for the modern bride. Here, Marcus Bell combined a bit of grain, noise, and blur to make it a very misty, romantic portrait.

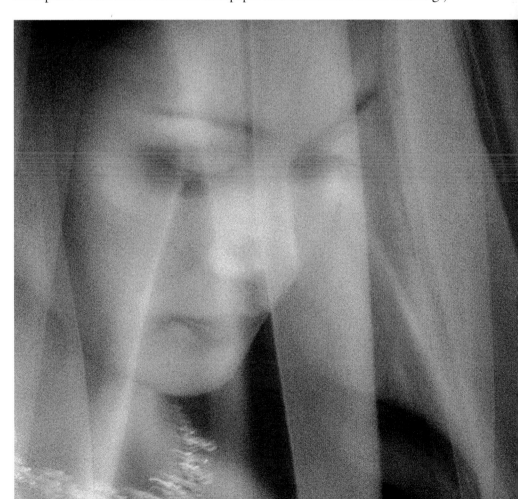

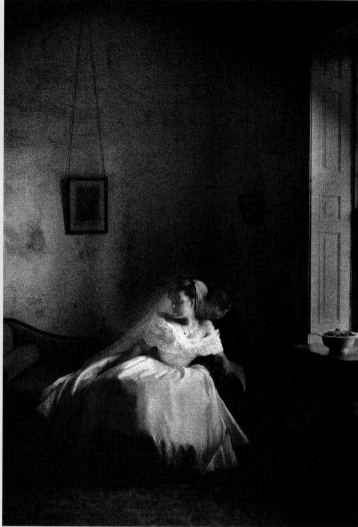

Martin Schembri's Posing Checklist

Australian photographer Martin Schembri has a posing checklist that he goes through each time he makes a bridal portrait. The checklist guarantees that the posing will at least start in a formal tone. He considers correct posing to be one of the most difficult things to achieve in a portrait of the bride. He says, "No matter how correct your lighting and other technicalities may be, if your posing appears contrived, uncomfortable, or unnatural, the photograph loses its essence. No matter what style your clients require—formal, relaxed, generic, or fashion—the basics are always called upon."

In order of importance, Martin first turns his subject's shoulders away from the camera—at, say, a 30-degree angle. This will help to create shape and is more flattering to the sitter. He will then turn his subject's head toward the camera. "Try to avoid square shoulders that are parallel to the lens," he says. "Depending upon the shape of the face, ensure that your camera height is at your subject's eye level."

The most common rule Martin follows to correct nose shapes is to lower the camera height to nose level and ask the sitter to turn their head so that the tip of the nose is pointing directly into the middle of the lens. This will help avoid any profiling and push the nose shape into the sitter's facial area. By using this flattering technique, you will help hide any abnormal nose shapes and sizes.

The next important feature is the hands. "Hands are an important feature that will help with the mood of the portrait you are creating. Always keep the subject's hands close to the body and natural in shape. If you prefer a formal feel, ask your sitter to pretend to hold a pen and raise the hand slightly at the wrist. Turn the hand away from the camera so that the thumb side is facing toward the body. Never point either hands and knees directly into the lens," says Martin.

LEFT—*Martin Schembri likes grainy, emotional renditions of his brides. The shoulders here are square to the camera, but the head is at a 30-degree angle with the eyes looking back toward the lens. Just a bit of the expertly posed hands are visible.*

RIGHT—*A tranquil eighteenth-century pose was created here by Martin Schembri using only daylight to illuminate the room. The pose turns the bride away from the light so that the frontal plane of the face is not lit—an unusual twist to the pose.*

The Veil. Make sure to get some close-ups of the bride through her veil. It acts like a diffuser and produces romantic, beautiful results. For these shots, the lighting should be from the side rather than head-on to avoid shadows on the bride's face caused by the patterned mesh.

Many pros use the veil as a compositional element in portraits. To do this, lightly stretch the veil so that the corners slant down toward the lower corners of the portrait. This forms a loose triangle that leads the viewer's eyes up to the bride's eyes.

Many pros use the veil as a compositional element in portraits.

Photographing the bride through her veil creates a lovely image. In this portrait by Marcus Bell, the image was made high key by overexposing and underprinting. It is beautiful by virtue of the image details it eliminates.

3. Corrective Posing Techniques

It's important to understand that people don't see themselves the way they actually appear. Subconsciously, they shorten their noses, imagine they have more hair than they really do, and in short, pretend they are better looking than they really are. A good portrait artist knows this and knows how to reflect the same level of idealization in portraits of the subject. As a matter of procedure, the photographer analyzes the face and body and makes mental notes as to how best to light, pose, and compose the subject to produce a flattering likeness. Because they are always shooting under pressure, wedding photographers must master these techniques to such a degree that they become second nature.

Camera Height and Perspective

Camera Height. When photographing people with average features, there are a few general rules that govern camera height. These rules will produce normal perspective with average people.

> **1.** For head-and-shoulders portraits, the rule of thumb is that camera height should be the same height as the tip of the subject's nose or slightly higher.
>
> **2.** For three-quarter-length portraits (portraits that include the subject's figure down to mid-calf or mid-thigh), the camera should be at a height midway between the subject's waist and neck.
>
> **3.** In full-length portraits, the camera should be the same height as the subject's waist.

In each case, notice that the camera is at a height that divides the subject into two equal halves in the viewfinder. This is so that the features above and below the lens/subject axis are all the same distance from the lens and thus recede equally for "normal" perspective.

Controlling the Perspective. As the camera is raised or lowered, the perspective (the size relationship between parts of the photo) changes. By controlling perspective, you can alter the physical traits of your subject.

By raising the camera height in a three-quarter or full-length portrait, you enlarge the head and shoulder regions of the subject, while slimming the hips

People don't see themselves the way they actually appear.

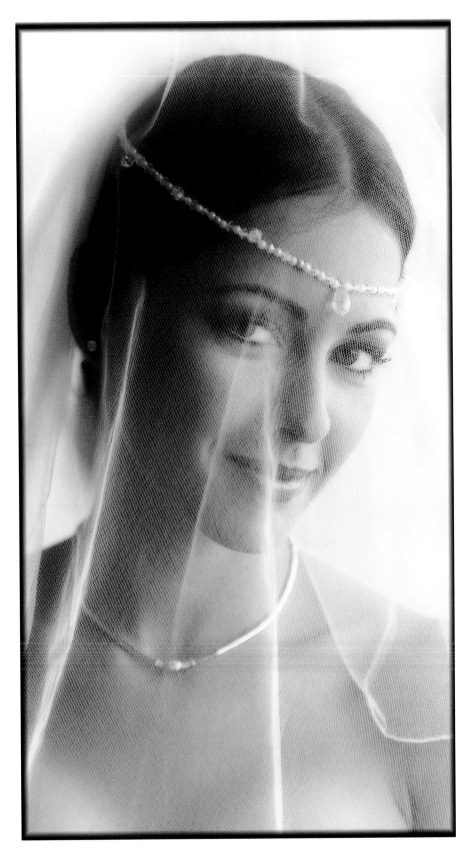

and legs. Conversely, if you lower the camera, you reduce the size of the head and enlarge the size of the legs and thighs. If you find that after you make a camera-height adjustment for a desired effect there is no change, move the camera in closer to the subject and observe the effect again.

Tilting the camera down when raising the camera (and up when lowering the camera) increases these effects. A good rule of thumb for three-quarter- and full-length portraits is to keep the lens at a height where the plane of the camera's back is parallel to the plane of the subject. If the camera is tilted up or down you will be distorting the person's features.

When you raise or lower the camera in a head-and-shoulders portrait, the effects are even more dramatic. Raising or lowering the camera above or below the subject's nose height is a prime means of correcting any facial irregularities. Raising the camera lengthens the nose, narrows the chin and jaw lines, and broadens the forehead. Lowering the camera shortens the nose, de-emphasizes the forehead, and widens the jaw while accentuating the chin.

Correcting Specific Problems

This section deals with posing methods to correct specific physical traits you will encounter with everyday people. While it's unlikely that you'll be able to control all (or even most) of the variables while shooting on the wedding day, you can be observant about

certain irregularities you encounter in the people you photograph. If you determine that a person has an unusually narrow face, for example, knowing what to do to correct that trait will be invaluable—after all, the key to a more appealing portrait might be as simple as turning the person into the light or away from it to broaden or narrow the face.

Overweight Subjects. Dark clothing will make a person appear ten to fifteen pounds slimmer. While this is is something you could recommend for the

Dark clothing will make a person appear ten to fifteen pounds slimmer.

A good rule of thumb when making a three-quarter-length portrait is to keep the camera back parallel to the plane of the subject. This reduces subject distortion and helps to keep horizontal and vertical lines true. Photograph by Kevin Jairaj.

Contouring with the Liquify Filter

Photoshop's Liquify function allows you to bend and twist a subject's features either subtly or dramatically, allowing you to address issues that were not completely corrected via posing or lighting.

Activating the Liquify function (Filter> Liquify), opens a full-screen dialog box with your image in the center. To the left of the image are a set of tools that let you warp, pucker, or bloat an area simply by clicking and dragging. There is even a tool that freezes an area, protecting it from the action of the tool. When you want to unprotect the area, simply use the thaw tool. To the right of the image, you'll find settings for the brush size and pressure.

Using this tool, it is a simple matter to give your subject a tummy tuck, or take off fifteen pounds with a few well-placed clicks on the hips and/or waistline. It is outrageous how simple this tool is to use, and

Jerry D, who specializes in digital makeovers, says his clients sometimes love a given picture but don't like something about their appearance in it. One bride said to him, "I love the photo, but can't you make me look thinner?" He said he could and proceeded to remove her arm in Photoshop and paste it back onto her recontoured body, which was made thinner with the Liquify filter. You cannot tell where the retouching was done and the bride was ecstatic over Jerry's magic.

the effects are seamless if done subtly. (If you notice that you have overdone it, however, there is even a reconstruct tool that undoes the effect gradually—like watching a movie in reverse.)

Be careful not to eliminate elements of the person's appearance that they actually like—these "flaws" are, after all, part of what makes every person unique. When this happens, you have gone too far. It is always better to approach this type of reconstructive retouching with a little feedback from your subject and a lot of subtlety.

The liquify function is like a separate application by itself. It will take some practice and experimentation to perfect the techniques. However, for the most commonly needed refinements of subject features, it is a snap.

engagement session, it's beyond your control at the wedding. Therefore, careful posing will be an important tool for addressing the issue. Begin by using a pose that has the subject turned at a 45-degree angle to the camera. Never photograph a larger person head-on; it will only accentuate their size. Standing poses are more flattering for overweight subjects. Seated, excess weight accumulates around the waistline. Selecting a pose that turns your subject away from the main light is also desirable, as this will put more of the body in shadow and produce a slimming effect.

Thin or Underweight Subjects. When posing a thin person, have him or her face the camera more directly to provide more width. Selecting a pose that turns your subject toward the main light is also desirable, as this will put more of the body in the light and produce a widening effect.

Elderly Subjects. The older the subject, the more wrinkles he or she will have. It is best to use some type of diffusion, but do not soften the image to the point that none of the subject's wrinkles are visible. Men, especially, should not be overly softened, as their wrinkles are often considered "character lines." In the absence of light modifiers, you can also pose the subject

Retouching: Teeth and Eyes

By quickly cleaning up eyes and teeth in Photoshop, you can put real snap back into the image. To do this, use the dodge tool at an exposure of 25 percent. Since the whites of the eyes and teeth are only in the highlight range, set the range to highlights in the options bar.

For the eyes, use a small soft-edged brush and just work the whites of the eyes— but be careful not to overdo it. For teeth, select a brush that is the size of the largest teeth and make one pass. Voilà! That should do it.

For really yellow teeth, first make a selection using the lasso tool. It doesn't have to be extremely precise. Next, go to Image>Adjustments>Selective Color. Select Neutrals and reduce the yellow. Make sure that the method setting, at the bottom of the dialog box, is set to Absolute, which gives a more definitive result in smaller increments. Remove yellow in small increments (one or two points at a time) and gauge the preview. You will instantly see the teeth whiten. Surrounding areas of pink lips and skin tone will be unaffected because they are a different color.

LEFT—The best retouching is that which you can't see. Cleaning up a few of the blood vessels in the eyes, blending the minor imperfections of the skin and a little bit of softening throughout is more than enough. Photograph by Jerry Ghionis.

so that the main light strikes primarily the front of their face, minimizing any deep shadows in the wrinkles and deep furrows of the face.

In general, older subjects should also be smaller within the composition. Even when making a head-and-shoulders portrait, reducing the subject size by about 10–15 from how you might normally frame the image will ensure that the signs of age are less noticeable.

Eyeglasses. With digital capture, it's easy to see if eyeglasses are captured with reflections. If you have a chance to retake the photo, have the person slide the eyeglasses down on his or her nose slightly. This changes the angle of incidence and helps to eliminate unwanted reflections.

One Eye Smaller than the Other. Most people have one eye smaller than the other. This should be one of the first things you observe about your subject. If you want both eyes to look the same size in the image, pose the subject in a seven-eighths to three-quarters view, placing the smaller eye closer to the camera. Because objects farther from the camera look smaller and nearer objects look larger, this will cause both eyes to appear to be more or less the same size.

Baldness. If your subject is bald, lower the camera height so less of the top of his head is visible. In post-production, you can also try to blend the tone of the background with the top of your subject's head.

Double Chins. To reduce the view of the area beneath the subject's chin, raise the camera height so that area is less visually prominent. You can also have the subject tilt their chin upward, tightening the area, and (if possible) raise the main light so that as much a possible of the area under the chin is in shadow.

With digital capture, it's easy to see if eyeglasses are captured with reflections.

Wide Faces. To slim a wide face, pose the person in a three-quarters view and turn them away from the main light. This places the image highlights on the narrow side of the face for a slimmer look.

Thin Faces. To round a narrow face, pose the person in a seven-eighths view, keeping as much of the face as possible visible to the camera. Turn them toward the main light to place the image highlights on the broader side of the face for a fuller look.

Broad Foreheads. To diminish a wide or high forehead, lower the camera height and tilt the person's chin upward slightly. Remember, the closer the camera is to the subject, the more noticeable these corrective measures will be. If you find that by lowering the camera and raising the chin, the forehead is only marginally smaller, move the camera in closer and observe the effect again—but watch out for other distortions.

Deep-Set Eyes and Protruding Eyes. To correct deep-set eyes, try having the subject raise their chin. To correct protruding eyes, have the person look downward so that more of the eyelid is showing.

Large Ears. To scale down large ears, the best thing to do is to hide the far ear by placing the person in a three-quarters view, making sure that the far ear is out of view of the camera (or in shadow). If the subject's ears are very large, examine the person in a profile pose. A profile pose will totally eliminate the problem. Also, longer length lenses will appear to compress the visible ear, reducing its prominence.

Uneven Mouths. If your subject has an uneven mouth (one side higher than the other, for example) or a crooked smile, turn his or her head so that the higher side of the mouth is closest to the camera, or tilt the subject's head so that the line of the mouth is more or less even.

Long Noses and Pug Noses. To reduce the appearance of a long nose, lower the camera and tilt the chin upward slightly. You should also select a frontal pose, either a full-face or seven-eighths view, to disguise the length of your subject's nose.

Long Necks and Short Necks. While a long neck can be considered sophisticated, it can also appear unnatural—especially in a head-and-shoulders portrait. By raising the camera height and lowering the chin you will shorten an overly long neck. When photographing a male subject, pulling up his collar will also shorten an overly long neck. Conversely, lowering the camera height and suggesting a V-neck shirt (for the engagement session, for example) will lengthen the appearance of a short neck.

Wide Mouths and Narrow Mouths. To reduce an overly wide mouth, photograph the person in a three-quarters view with no smile. For a narrow or small mouth, photograph the person in a more frontal pose and have him or her smile broadly.

Long Chins and Stubby Chins. Choose a higher camera angle and turn the face to the side to correct a long chin. For a stubby chin, use a lower camera angle and photograph the person in a frontal pose.

To diminish a wide or high forehead, lower the camera height and tilt the person's chin upward slightly.

4. Design Elements and Posing

The Concepts of Visual Design

The basic concepts of visual design are not unique to photography, they can be found in all forms of visual expression dating back to the ancient Greeks. They are methods of effective visual communication, on both an obvious and a subliminal level, that influence the viewer's perception of an image.

Even artists who are not consciously aware of these guidelines sometimes instinctively use them because they have an innate sense of when things just "look right." For the rest of us, these principles can be observed in all forms of visual art, then implemented in our own creations. The more you become familiar with the visual rhythms that govern how people perceive images, the better you will be able to incorporate these elements into your photographs.

How is this relevant to the art of posing, you might ask? Where and how the subject is posed is one of the most critical elements in creating a well-designed image with strong visual impact. Using the principles of design and composition, you will find the means to create truly expressive statements—images that will engage the viewer long after the surface information has been assimilated. Additionally, the elements of formal posing, discussed in the previous chapters, can often lead to somewhat static compositions. These concepts of visual design are a few guidelines that will keep your posed images dynamic and fresh.

Composition

Many photographers don't know where to place the subject within the frame and, as a result, opt to place the person in the center of the picture. This is the most static type of portrait you can produce.

The easiest way to improve your compositions is to use the rule of thirds. Examine the rule-of-thirds diagram that appears to the right. The viewing area is cut into nine separate squares by four lines. Where any two lines intersect is an area of dynamic visual interest and an ideal spot to position your main point of interest. Placement of the center of interest anywhere along one of the dividing lines can also create an effective composition.

In head-and-shoulders portraits, for example, the eyes would be the area of central interest. Therefore, it is a good idea if they fall on a dividing line or at an intersection of two lines. In a three-quarter- or full-length portrait, the

The rule of thirds breaks the frame area into nine quadrants with four distinct intersections. Those intersections correspond to areas on which to position a main center of interest. Some DSLR viewfinder grids allow you to call up a grid screen that superimposes over the viewfinder screen, giving you a guideline as to those crucial points.

This wonderful bridal portrait by Dan Doke has a well-defined sense of direction. The eye follows the strong diagonal lines of the steps and the angle of the bride up to the faces of the bride and groom, which are the main center of interest and positioned close to an intersection of the rule of thirds lines.

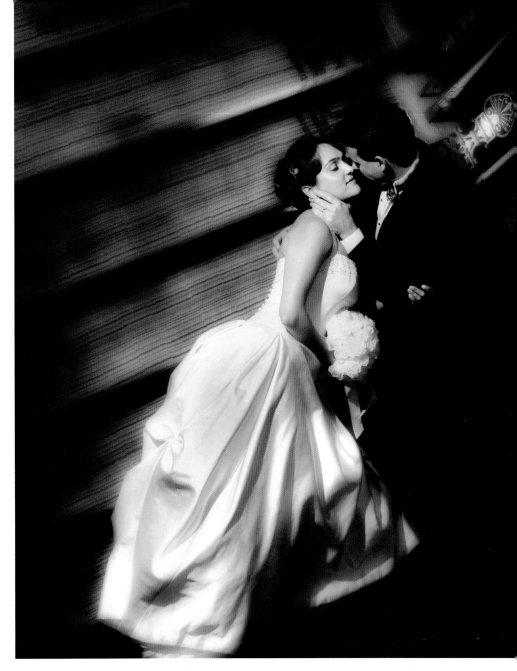

Every good portrait has a sense of direction.

face is the center of interest. Thus, the face should be positioned to fall at an intersection or on a dividing line.

Usually, the head or eyes are two-thirds from the bottom of the print in a vertical photograph. In a horizontal composition, the eyes or face are usually at the top one-third of the frame—unless the subject is seated or reclining. In that case, they might be at the bottom one-third line.

Direction

Every good portrait has a sense of direction. This is most easily accomplished by leaving more space in front of the subject than behind the subject. Perceptually, this "off-centering" provides a sense of movement and direction.

For example, if you are photographing a subject who is looking toward camera right, you should leave slightly more space on the right side of the

frame (the side to which the subject is looking) than on the left side. How much space should be included in each portrait is a matter of artistic taste and experience.

Even if the composition is such that you want to position the person very close to the center of the frame, there should still be slightly more space on the side toward which the subject is turned.

Lines

Real Lines. To effectively master the fundamentals of composition, the photographer must be able to recognize real and implied lines within the photograph. A real line is one that is obvious—a horizon, for example. Real lines should not intersect the photograph in halves. This actually splits the com-

BELOW—The impact of strong lines in a photograph can't be underestimated. In this image, Joe Buissink used the powerful line of the adobe staircase to dissect the image into two nearly equal quadrants. The power of the diagonal seems to propel the bride upward. Further, the visual contrast between the three different shades of paint delights the eye, as if the bride is strolling through a painting.

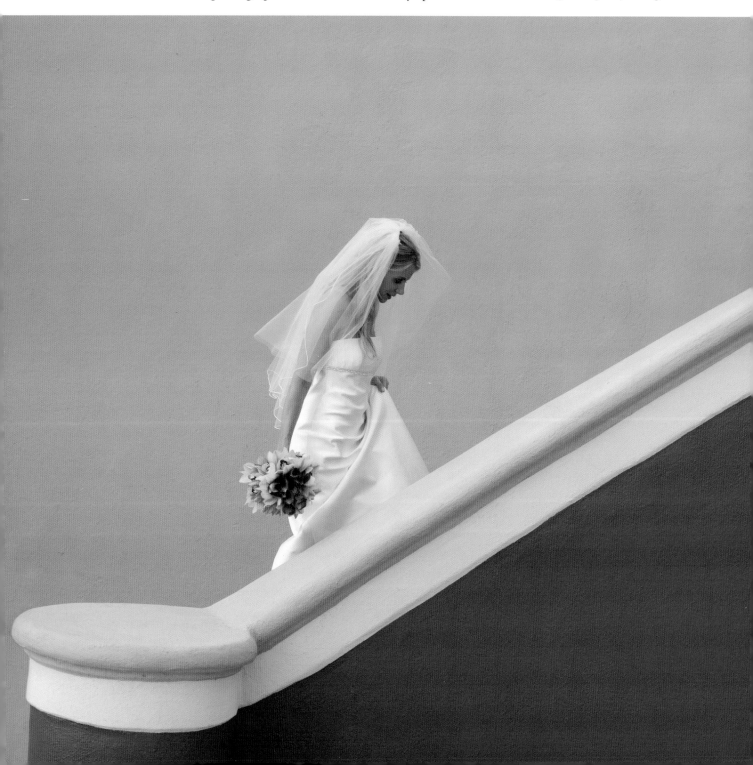

position into separate pictures. It is better to locate real lines at a point one-third into the photograph, thus providing visual "weight" to the image.

Implied Lines. An implied line is one that is not as obvious, like the curve of the wrist or the bend of an arm. Implied lines, such as those of the arms and legs of the subject, should not contradict the direction or emphasis of the composition, but should modify it. These lines should add gentle changes in direction and lead to the main point of interest—either the eyes or the face.

All lines, either real or implied, that meet the edge of the photograph should lead the eye into the scene, not out of it; they should lead toward the main center of interest.

Diagonal Lines. It should be noted that the use of lines is one of the main tools a photographer has for giving a photograph a sense of dynamics. It is im-

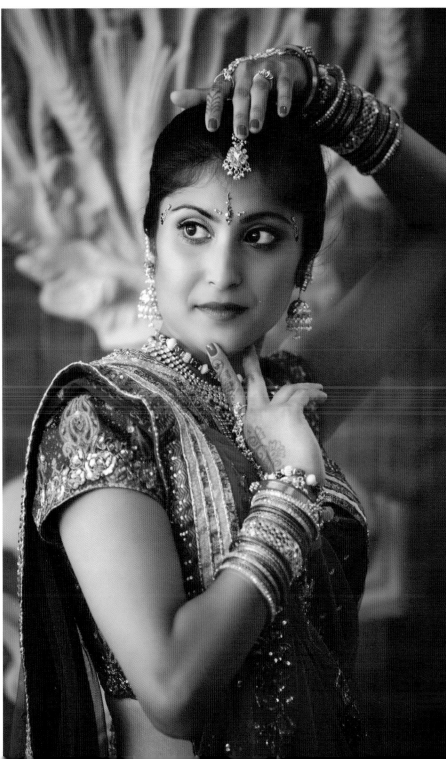

portant to remember that horizontal and vertical lines are basically static by nature and mimicked by the horizontal and vertical edges of the print. A diagonal line, on the other hand, provides a gently sloping path for the viewer's eye to follow—making this kind of line much more interesting. In the work of great photographers, diagonal lines often enhance the composition.

Shapes

Shapes are basic geometric forms, made up of implied or real lines, within a composition. For example, a classic way of posing three people is in a triangle or pyramid shape. You might also remember that the foundation of any well-composed portrait is the triangular base.

Shapes, while more dominant than lines, can be used similarly in unifying and balancing a composition. Sometimes shapes may also be linked by creating a common element between multiple groups. For example, two groups of three people in pyramid shapes can be linked by a person in between—a common technique used when posing groups of five or more people.

There are an infinite number of possibilities involving shapes, linked shapes, and even implied shapes. what's important is to be aware that shapes and lines are prevalent in well-composed images and are a vital tool in creating visual interest within a portrait.

Pleasing Compositional Forms

Shapes in compositions provide visual motion. The viewer's eye follows the curves and angles as it makes its way logically through the shape, and conse-

This wonderful image is a mosaic of lines and shapes. The main shape is the massive triangle that frames the photo. Further, two perfectly vertical columns stand on either side of the bride and groom, contrasting the powerful diagonal lines of the staircase and balcony. Variations of squares and diagonals, make this image a visual feast. Photograph by Cherie Steinberg Coté.

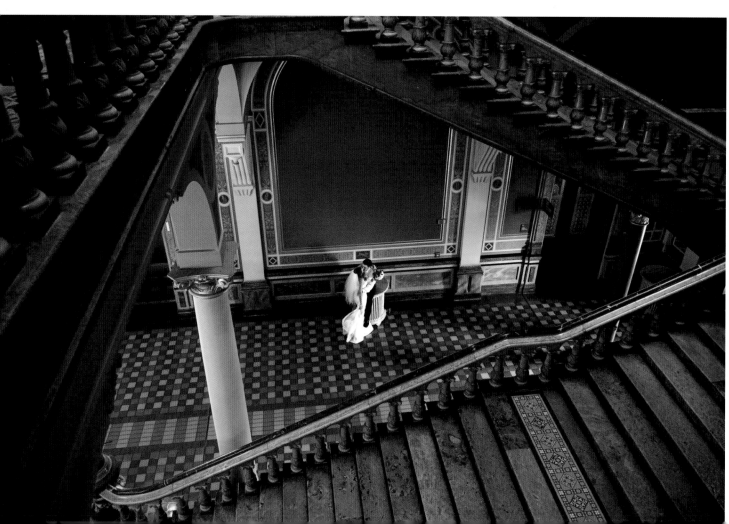

quently, through the photograph. The recognition and creation of found and contrived compositional forms is another of the photographer's tools in creating a dynamic portrait.

The S-shaped composition is perhaps the most pleasing of all compositions. The center of interest will usually fall in one of the dynamic quadrants of the image (one of the intersections of the rule-of-thirds grid [see page 48]), but the remainder of the composition forms a gently sloping S shape that effectively leads the viewer's eye to the area of main interest.

Another pleasing type of composition is the L shape or inverted-L shape. This occurs when the subject's form resembles the letter L or an inverted letter L. This type of composition is ideal for reclining or seated subjects. The C and Z shapes are also seen in all types of portraiture, and both are visually pleasing.

The classic pyramid shape is one of the most basic in all art, and is dynamic because of its use of diagonals with a strong horizontal base. The straight road receding into the distance is a good example of a found pyramid shape.

Subject shapes can be contrasted or modified with additional shapes

The statuesque bride and her shadow are the only static lines in a composition filled with whirls and twirls and curved shapes. The image, made by Cherie Steinberg Coté at the Walt Disney Concert Hall in Los Angeles, shows great visual motion. The bride and her shadow stride toward the canyon of curving stainless steel walls, creating the illusion of movement.

found either in the background or foreground of the image. The lead-in line, for example, is like an arrow directing the viewer's attention to the subject.

Tension and Balance

Just as real and implied lines and real and implied shapes are vital parts of an effectively designed image, so are the "rules" that govern them—the concepts of tension and balance.

Tension occurs when there is a state of imbalance in an image. Pairing a big sky with a small subject, for example, creates visual tension. Balance oc-

curs when two items, which may be dissimilar in shape, create a harmony in the photograph because they are of more or less equal visual strength.

Although tension does not have to be resolved in an image, it works together with the concept of balance so that, in any given image, there are elements that produce visual tension and elements that produce visual balance. This is a vital combination of artistic elements, because it creates a sense of heightened visual interest.

Tension can also be referred to as visual contrast. For example, a group of four children on one side of an image and a pony on the other side of the image produce visual tension. They contrast each other because they are different sizes and they are not at all similar in shape. However, the photograph may still be in a state of perfect visual balance by virtue of what falls between these two groups—or for some other reason. For instance, these two groups could be resolved visually if the children, the larger group, are wearing bright

This is a vital combination of artistic elements, because it creates a sense of heightened visual interest.

This is a great example of tension and balance working together to produce a strong dynamic image. The visual tension arises from the two main areas of interest: the couple and the palm tree. Your eye plays ping-pong between the two areas. Even though they are of dissimilar size and shape, they balance one another perfectly creating an odd sort of visual harmony within the photo. Another intended area of tension is the crooked line of the wall, which the eye tends to want to straighten out. Photograph by Cherie Steinberg Coté. The custom border is designed by Cherie and is part of her Edgy Girl collection (www.edgygirl.com).

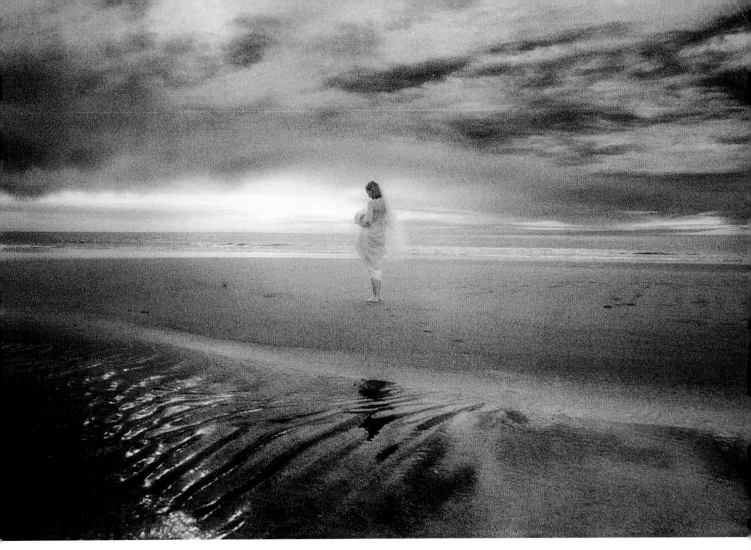

The bride occupies very little space in this panoramic image by Joe Buissink. Further, her tonality is very similar to that of the surrounding area. Yet there is no wandering from her figure as she is symmetrically dead-center in the frame. What's at work here is a selective vignetting of the corners, each one different, which holds the eye inside the frame. The sun is, of course, the brightest area in the image, and your eye is drawn toward it. This is why the bride is positioned so close to that area of the image.

clothes and the pony is dark colored. The eye then sees the two units as equal—one demanding attention by virtue of size, the other gaining attention by virtue of brightness.

Subject Tone

Generally, the eye is drawn to the lightest part of a photograph. This is because light tones advance visually, while dark tones retreat. This means that elements in the picture that are lighter in tone than the subject will be distracting. For this reason, bright areas (particularly at the edges of the image) should be darkened either in printing, in the computer, or in the camera so that they do not draw attention from the subject.

Whether an area is in or out of focus also has a lot to do with the visual emphasis it will receive. For instance, imagine a subject framed in green foliage with part of the sky visible. The eye would ordinarily go to the sky first. If the sky is soft and out of focus, however, the eye will revert back to the area of greatest contrast—usually the face. The same is true of the foreground. Although it is a good idea to make this darker than your subject, sometimes you can't. If the foreground is out of focus, however, it will detract less from a sharp subject.

Regardless of whether the subject is light or dark, it should dominate the rest of the photograph either by brightness, size, or contrast.

Background Control

The best type of background for a portrait is monochromatic. If the background is all the same color, the subjects will stand out from it. Problems arise when there are bright areas or other distracting elements in the background. These can effectively be minimized by shooting at wide lens apertures, since the shallow depth of field will blur the background, reducing distracting detail and merging light and dark tones.

Another way to minimize a distracting background is in post-production. By burning-in or diffusing the background you make it darker, softer, or more uniform in tone. This technique is simple in Photoshop, since it's fairly easy to select the subjects, invert the selection so that the background is selected, and perform all sorts of maneuvers on it, from diffusion, to color correction, to density correction.

Tilting the Camera

You will often see the camera tilted. This can be for dynamic effect—but there are other reasons, as well. Tilting the camera may also allow the photographer to raise or lower the line of the shoulder, for a more pleasing pose. With wide-angle lenses, tilting the camera may take the subject's

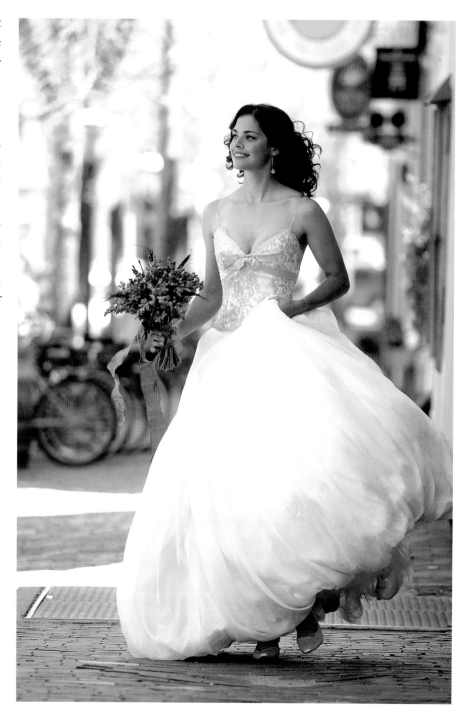

Background control is imperative in an image like this. The background is brighter and has more contrast than the area where the bride is posed in shade. The photographer, Claudia Kronenberg, wisely chose a telephoto focal length (180mm), a wide-open aperture of f/2.8, and a fast shutter speed to capture the bride. The wide aperture and long lens blurred the background so that it became a muted pastel backdrop.

face away from frame edges, causing there to be less distortion in the crucial areas of the image, but still allowing the pictorial effects of the wide-angle to be enjoyed.

5. Group Posing and Composition

When more than one person is pictured in a portrait, the traditional rules of portraiture, refined throughout the centuries, have to be bent—if not shattered completely. As one noted wedding and portrait photographer Norman Phillips says, "The most important concern in building groups is to be sure they are in focus and properly lit." In traditional portraiture of a single person, the fundamentals of posing and composition help define character in the image; in a group portrait, it is the design created by more than one person that helps to define the image. As you will see, there are a number of tricks at play that you have probably never noticed.

Try Something Unique

Even with elegant posing and lighting, shots can look similar if they are arranged similarly—bride and groom in the middle, bridesmaids and groomsmen staggered boy-girl on either side, etc. In contrast, when a wedding photojournalist makes groups, he or she might make them from the top of a

Traditionally, big groups, like the wedding party, are arranged in staggered fashion—boy, girl, boy, girl, etc. This is a standard group posing, but it is excellently done. All the head-and-shoulders axes have been controlled and the poses are all good. All the group members face the center where the bride and groom are, and the lighting is also great—a combination of directional shade and weak fill flash. Photograph by Joe Photo.

ABOVE—Here's a crazy variation of the boy-girl pose by JB and DeEtte Sallee. Notice that the two groomsmen at both ends of the group have their arms raised, pointing back to the middle. The posing is not out of control, as it might seem it first, but rather well choreographed. The photographers broke up the big group into smaller subgroups, each of which is doing something different.

LEFT—With good posing dynamics, the head-and-shoulders axes are different but similar from subject to subject. Here, Marcus Bell arranged the subjects close together for an intimate group pose. The image is lit from a large sliding glass door in the bride's suite.

stairwell or put them all in profile marching down a beach with the grooms-men's pants rolled up and the bride and bridesmaids holding their dresses at knee height, or do something otherwise unpredictable and different.

Head and Shoulders Axis

One of the fundamentals of good portraiture is that the subjects' shoulders should be turned at an angle to the camera. When the shoulders face the camera straight on, it makes people look wider than they really are and can lead to a static composition.

Not only should the shoulders be at an angle, so should each subject's head. This is known as the head-and-shoulders axis, each having a different plane and angle. Technically speaking, these are imaginary lines running through shoulders (shoulder axis) and down the ridge of the nose (head axis).

Head-and-shoulder axes should never be perpendicular to the line of the lens axis.

With men, the head is more often turned the same direction as the shoulders, but not neces-

LEFT—Here is an interactive pose by Marcus Bell. It is a walking pose and, as a result, one of the group members is obscured by the groom. The expressions and interaction are first rate, making this a fine group with a minimum of posing.

BELOW—This is a more traditional pose in that the groomsmen are facing in toward the groom and the head and neck axis positions are good and natural. The slope of the curving hilltop gives the image an interesting dynamic. This is the kind of interesting group shot that the couple loves to include in the album. Photograph by Dan Doke.

sarily to the same degree. With women, the head is often at a slightly different and opposing angle.

One of the by-products of good posing is the introduction of dynamic lines into the composition. The line of the shoulders now forms a diagonal line, while the line of the head creates a different dynamic line.

Head Positions

Knowing the different head positions, outlined on pages 30–32, will help you provide variety and flow in your group designs. You may, at times, end up using all three head positions in a single group portrait. The more people in the group, the more likely that becomes. Keep in mind that, with all three of these head poses, the shoulders should be at an angle to the camera.

Expressions

One of the best ways to enliven a group's eyes is to entertain them. If they enjoy your banter, their eyes will smile, which is one of the most endearing expressions a person can make.

When photographing groups of any size, you will undoubtedly get some "blinkers." Be on the lookout and if you suspect one of the group blinked during the exposure, they probably did. This problem gets worse as the group gets larger. One trick that works with chronic blinkers is used by Florida pho-

If you examine each of the expressions in this portrait, entitled *Messed up in Mexico,* you will see that the group is completely unaware of the camera and having a wonderful time. The idea to go out and sit on the dock was no doubt originated by the photographers, JB and DeEtte Sallee.

tographer Kathleen Hawkins, who has her group subjects look down and then look up at the count of three. All this is done with the groups' eyes wide open and it seems to work.

Also crucial in tightly packed groups is making sure that the camera sees the entire face of each subject. This is especially true with kids, who will often try to hide behind their mom or big sister so the camera can only see one eye. The best tip is to tell the group, "Make sure you can see the camera with both eyes." If they can, you'll get full faces in your groups.

When shooting large groups, it is inevitable that you will get one or more people looking away or blinking during the exposure, so make it a habit to shoot a few extra frames so that you can "swap heads" in postproduction. Copying/pasting one head into another portrait to replace a blink or bad expression is commonplace these days and takes a minimum of effort on the part of the photographer. Simply select the "good head," copy it, then paste it into a new layer in the best original of the group. It should only take a few seconds. With this technique, there's no excuse for blinks or poor expressions in your group images.

Hands in Group Portraits

Hands can be a problem in groups of any size. Despite their small size, they attract attention to themselves, particularly against dark clothing. They can be

This is an "after the posed shot was made" image by Marcus Bell. It is an interactive pose that is full of animation as the girls relaxed after their group portrait. What's interesting is that they held their pose and that only a few hands are visible. Most are hidden from view—and if they are visible, they are clearly seen and well posed. This is one of the basics you must remember when photographing groups: be cognizant of partial hands.

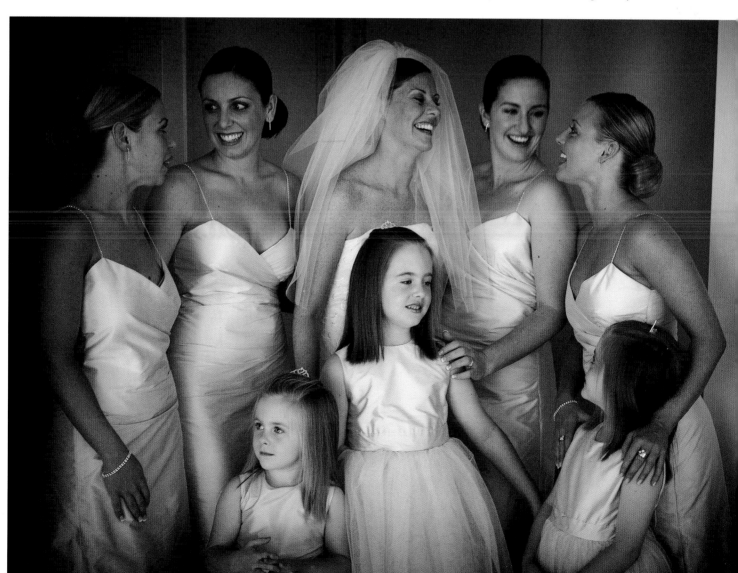

especially problematic in seated groups, where at first glance you might think there are more hands than there should be for the number of people pictured. Be aware of these potentially distracting elements and look for them as part of your visual inspection of the frame before you make the exposure.

Award-winning wedding photographer Ken Sklute makes it a point to eliminate as many hands as possible in his group portraits. For men, Ken has them put their hands in their pockets (a good look is to hitch the thumb on the outside of the pocket). For women, try to hide their hands in their laps or behind other people in the group. Flowers, hats, and other objects can also be used to hide hands in group portraits.

If you are photographing a man, folding the arms across his chest is a good, strong pose. Have the man turn his hands slightly inward, so the edge of the hand is more prominent than the top (this gives a natural line and eliminates distortion from photographing from the top or head-on). In such a pose, have him lightly grasp his biceps—but not too hard, or it will look like he's cold. Also, remember to instruct the man to bring his folded arms out from his body a little bit. This slims the arms, which would otherwise be flattened against his body, making them and him appear larger.

Women's hands should look graceful. With a standing woman, one hand on a hip and the other at her side is a good standard pose. Don't let the free

With larger groups, it's best to hide the hands as much as possible. That is what Jeff Kolodny did in this fisheye portrait made from above with a 10.5mm lens. You will notice that if you get the people too close to the frame edges that they will distort. Also note the great expressions!

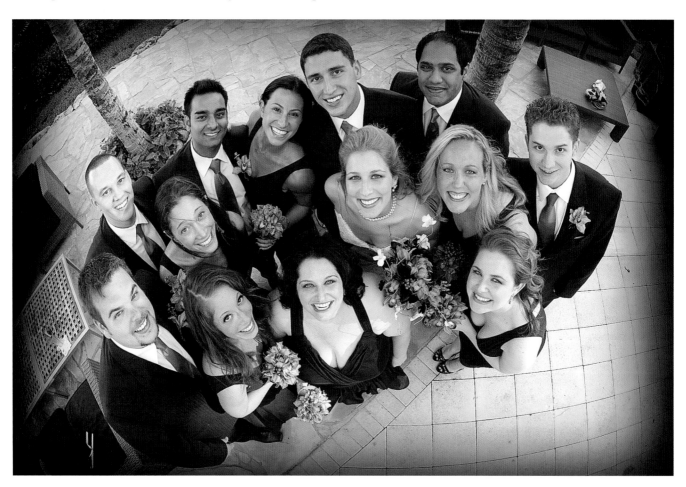

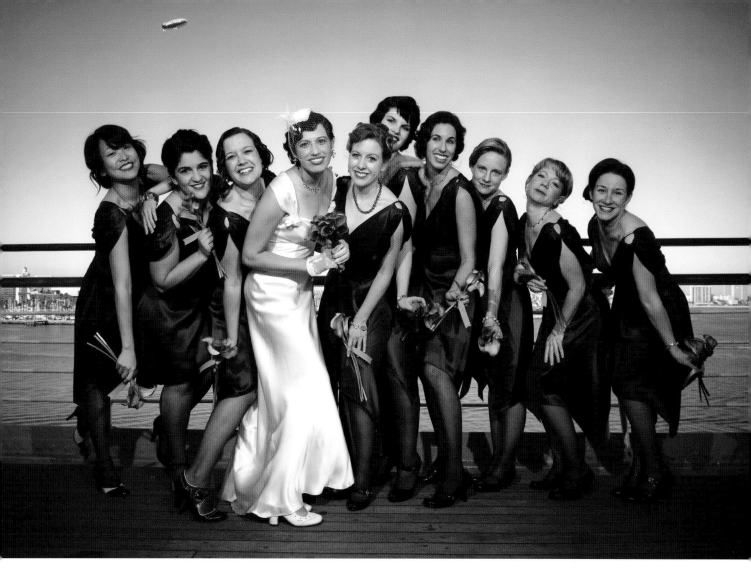

In this great group portrait made by Cherie Steinberg Coté aboard the Queen Mary in Long Beach, CA, Cherie allowed only one hand to show from each bridesmaid. The bride, however, holding her bouquet, has both hands visible. The hands are naturally posed. Cherie made this shot with two hot lights on stands (and help from her assistant). Cherie was determined to get the Goodyear blimp in the shot, which she did—as if it were on cue.

hand dangle. Instead, have her turn the hand so that the outer edge shows to the camera. Try to "break" the wrist, meaning to raise the wrist slightly so there is a smooth bend and gently curving line where the wrist and hand join. This is particularly important with women whose hands are small, since the "break" in the wrist gives the hand dimension.

In all types of portraiture, a general rule is to show all of the hand or none of it. Don't allow a thumb or half a hand or a few fingers to show. Additionally, you should avoid photographing subjects with their hands pointing straight into the camera lens. This distorts the size and shape of the hands. Instead, have the hands at an angle to the lens. Finally, try to photograph the fingers with a slight separation in between them. This gives the fingers form and definition. When the fingers are closed tightly together they tend to appear two-dimensional.

Designing Group Portraits

There are a number of ways to look at designing groups. The first is a technical aspect. Design your group so that those posed in the back are as close as possible to those in the front. This ensures that your plane of focus will

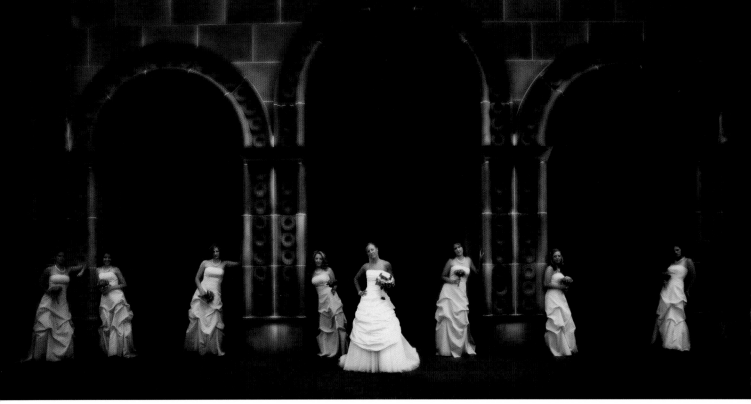

cover the front row as well as the back row. Ensuring such an arrangement is a good habit to get into if you want your groups to be sharply focused.

The second consideration in designing groups is aesthetic. You are building a design when creating a group portrait. Norman Phillips likens group design to a florist arranging flowers. He says, "Sometimes we might want a tight bouquet of faces. Other times we might want to arrange our subjects so that the group looks interesting apart from the dynamics of the people in the group." In other words, sometimes the design itself can be what's important.

A third consideration is proximity. How close do you want the members of the group to be? Phillips relates proximity to warmth and distance to elegance. If you open the group up, you have a lot more freedom to introduce flowing lines and shapes within the composition. On the other hand, a tightly arranged group where members are touching implies warmth and closeness.

Composition Basics Still Apply. When working with groups, the rules of composition (like the rule of thirds covered in chapter 4) remain the same, but several key members of the group become the primary area of interest. In a wedding group, the bride and groom are usually the main centers of interest and, as such, should occupy a prime location.

Creating Lines and Shapes. Implied and inferred lines and shapes are created by the placement of faces within the frame. These become all the more important in group portraits, as they are the primary tool used to produce pleasing patterns within the composition and guide the eye through the picture.

This means that no two heads should ever be on the same level when next to each other, or directly on top of each other. Not only should heads be on different levels, but the subjects should be as well. In a group of five people,

This is a carefully designed and expertly executed group by Kevin Jairaj. You have three subgroups set inside three arches. Each group is carefully arranged to create a V shape. The strength of the group arises from its asymmetrical nature (three, three, and two). Notice that the bride is the only one in a formal pose. She has good posture, with her weight on the back foot and standing erect. This contrasts with the tilted poses of the bridesmaids.

you can have all five on a different level—for example: one seated, one standing to the left or right, one seated on the arm of a chair, one kneeling on the other side of a chair, one kneeling down in front with their weight on their calves. Always think in terms of multiple levels. This makes any group portrait more pleasing.

The bigger the group, the more you must depend on your basic elements of group portrait design—circles, triangles, inverted triangles, diagonals, and diamond shapes. You must also really work to highlight and accentuate lines, real and implied, throughout the group. If you lined people up in a row, you would have a very uninteresting "team photo," a concept that is the antithesis of fine group portraiture.

The best way to previsualize this effect is to form subgroups as you start grouping people. For example, how about three bridesmaids here (perhaps forming an inverted triangle), three sisters over on the right side (perhaps

The bigger the group, the more you must depend on your basic elements of group portrait design.

TOP—Notice the different head heights in this group portrait. They're like musical notes on a score. The photographer, Marcus Bell, arranged the group into five neatly organized subgroups to give the overall gathering some dynamics. It is very effective and an attractive means of photographing a big group, like the bridal party.

BOTTOM—Dissect this attractive pyramid-shaped group by South African photographer Brett Florens and you will see three straight lines and three groups of three, using the center-most standing girl in two groups. Good groups are nothing more than a careful arrangement of subgroups linking shapes and lines.

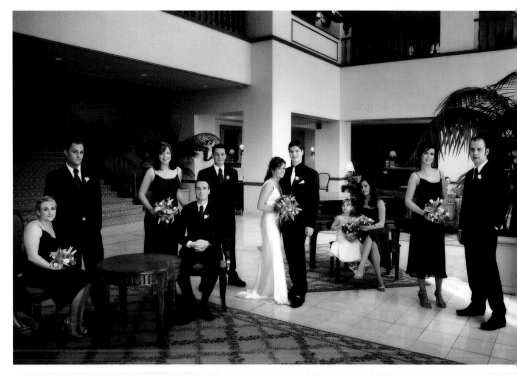

forming a flowing diagonal line), a brother, a sister and their two kids (perhaps in a diamond shape with the littlest one standing between her mom and dad). Then combine the subsets, linking the line of an arm with the line of a dress. Leave a little space between these subgroups, so that the design shapes you've formed don't become too compressed. Let the subgroups flow from one to the next and then analyze the group as a whole to see what you've created.

Remember that arms and hands help complete the composition by creating motion and dynamic lines that can and should lead up into the subjects' faces. Hands and arms can "finish" lines started by the basic shape of the group.

Just because you might form a triangle or a diamond shape with one subset in a group does not mean that one of the people in that group cannot be used as an integral part of another group. You might find, for example, that the person in the middle of a group of seven unites two diamond shapes. In a portrait like this, each subset could be turned slightly toward the center to unify the composition or turned away from the center to give a bookend effect.

Be aware of intersecting lines that flow through the design. Diagonal lines are by far the most compelling visual line and can be used repeatedly without fear of overuse. The curving diagonal is even more pleasing and can be mixed with sharper diagonals within the composition.

Also, keep an eye on equalizing subject proximity—don't have two heads close together and two far apart. There should be equal distance between each of the heads. If you have a situation where one person is seated, one standing, and a third seated on the arm of the chair (placing the two seated heads in close proximity), back up and make the portrait a full-length. This minimizes the effect of the standing subject's head being far from the others.

This wonderful portrait is not only a good group portrait, but a storytelling image as well. The bridesmaids, intent and confident they can fix the flowergirls' hair, are hard at work, while the younger girls look at one another incredulously. Notice, too, the interplay of cohesive lines within the composition, which keep your eye within the circle of girls and tie the individuals together in an integrated composition. Photograph by Kevin Jairaj.

Helpful Posing Tools

Armchairs, Love Seats, and Sofas. Once you begin adding people to a group, one of your most important props will be the stuffed armchair, small sofa, or love seat. Its wide arms, and often attractively upholstered surface, is ideal for supporting additional group members.

The armchair should usually be positioned at about a 30 to 45 degree angle to the camera. For a group of two, seat one person (following the guidelines in chapter 2) and either stand the second person facing the chair (for a full-length picture) or seat the second person on the arm of the chair, turning them in toward the seated person. The body of the person seated on the arm should be slightly behind the person seated in the chair, with their arm coming straight down behind the person seated slightly in front of them.

When adding a third person to the group, you can either seat the person on the other chair arm or stand them. If standing, that person should have their weight on their back foot, lowering the back shoulder. All three heads should be equidistant. A fourth person can then easily be added in a standing position, facing toward the center of the group.

From there on, it's just a question of adding faces where they need to be to continue the flow of the composition. You can fit someone squatted down

LEFT—Dan Doke created this bouquet-like group of bride and bridesmaids upon a flowered carpet that reminds you of the rose-petal bouquets. Note the proximity of the girls to one another and the bright expressions. Dan was directly overhead prompting the pose.

RIGHT—Contrast this portrait with the bouquet photo on the left. In this loosely composed group, the mom and dad are separated from the bride, who is in the foreground. The parents are acting as background elements and, in fact, aren't even in focus. The composition is an inverted triangle with the bride at the point of prominence in the design. Photograph by Tom Muñoz.

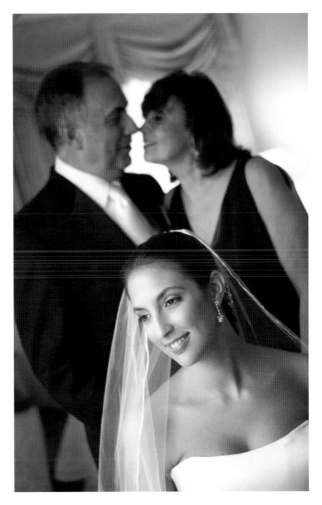

in the middle of the group, covering a lot of legs. You can have people kneel down on either side of the group (or seated on the ground) to complete the pyramid composition. This little group can easily become a group of fourteen. Just follow the rhythm throughout the group. Look for the triangles between heads, diagonal lines, and equal spacing between all of the faces.

Steps, Stairs, and Slopes. What about outdoors or on location, like at a wedding reception? You must find a spot—a hillside, steps, or staircase—that will be relatively comfortable for the duration of the session. These allow you to achieve the same objective as the chair: placing the heads of the subjects at different heights throughout the frame.

The Posing Process

Even experienced group photographers working with assistants will need ten minutes or so to set up a group of twenty or more. Therefore, selecting natural poses—ones that your subjects might fall into without prompting—will yield the greatest success.

It is important that the group remains alert and in tune with what you are doing, so it is critical to stay in charge of the posing. The loudest voice, the one that people are listening to, should be yours. By no means should you be

It is important that the group remains alert and in tune with what you are doing.

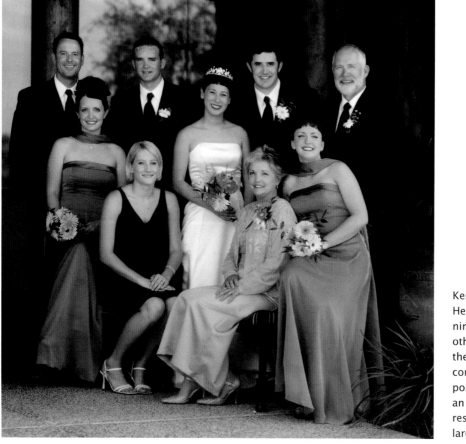

Ken Sklute is a master at posing groups. Here he used a settee to pose a group of nine. The settee seats two, facing each other. The arms of the settee hold two and the bride stands in between, producing a corresponding set of triangles. The men, positioned tallest toward the middle, form an arch across the back of the group. The result is an elegant but comfortably posed large group portrait.

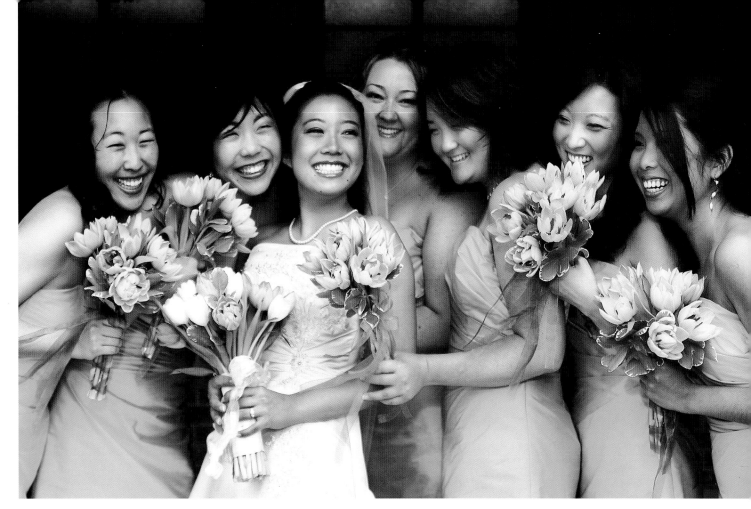

When designing groups, it is essential that you opt for either intimacy (closeness to one another) or elegance (distance from one another). Here, Robert Scott Lim opted for intimacy. He had the girls bring their bouquets up so that he could capitalize on all that color and crop the portrait tightly. Then he squeezed the group together, having the girls lean in toward the bride. This kind of pose works well when the expressions are full of life, as they are here.

yelling at the group, of course, but you must be assertive, positive, and firm—and act in control.

Show your subjects how you want them to pose, rather than telling them; it's much easier and takes less time. It also gives them a chance to have a good laugh. I recently saw a video of Yervant showing a bride how to dance down the aisle. Seeing Yervant, who is short and—to be honest—not that good a dancer, coming down the aisle with cameras flying back and forth around his neck looked rather like a circus act. Everyone in attendance was laughing hysterically. Because he's a pro, though, Yervant's "dance" only made the atmosphere better and the pictures more inspired.

Talk to your subjects constantly. Reassure them, laugh with them, and tell them they look good. People always respond positively to compliments. If you want to evoke a special emotion, ask them for it. You can also do what Jerry Ghionis does, asking, "What if . . .?" What if you did this, or moved here, or said this or that? It's like an indirect command, but seems to work well. If closeness is what you are after, ease them into it. It sounds hokey, but if it does nothing more than relax your subjects, you have done a good thing.

Building Smaller Groups

Start with Two. The simplest of groups is two people. Whether the group is a bride and groom, brother and sister, or grandma and grandpa, the basic

building blocks call for one person slightly higher than the other. Generally speaking, the mouth height of the higher subject should be at the forehead height of the lower subject. Many photographers recommend mouth to eyes as the ideal starting point. Also, since this type of image will be fairly close up, you will want to make sure that the frontal planes of their faces are roughly

You will want to make sure that the frontal planes of their faces are roughly parallel.

TOP—Walking poses are very popular. Because walking is a type of animated posing, the stride will look completely natural. Here Nick Adams used a 70-200mm lens set to 160mm at f/4 to produce a shallow band of depth of field that renders both foreground and background blurry, which is ideal for the mood of the photo and the late afternoon light. Remember, the smallest group is the couple.

BOTTOM—Marcus Bell captured this wonderful portrait of three completely different expressions, perhaps with a little coaxing or perhaps in reaction to his dialog. Each personality is clearly defined: the extrovert, the shy one, and the unhappy one. Also note the triangle shape, which contrasts the mirror on the wall picturing the bride, rendered truly.

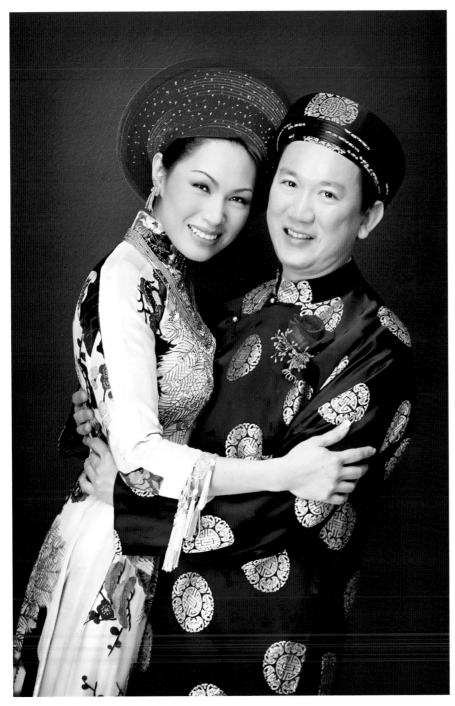

parallel so that you can hold the focus in both faces.

Although they can be posed in a parallel position, each with their shoulders and heads turned the same direction—as one might want to do with twins, for example—a more interesting dynamic can be achieved by having the two subjects pose at 45-degree angles to each other so their shoulders face in toward one another. With this pose you can create a number of variations by moving them closer or farther apart.

You can also have two profiles facing each other—just be sure that one subject is higher than the other, creating an implied diagonal line between their eyes and giving the portrait direction. An equally interesting pose, especially with bride and groom, is to place them back to back so they are facing away from each other. Then ask them what each is thinking about and be prepared for a spontaneous, fun reaction.

Using an armchair allows you to seat one person, usually the woman, and position the other person close and seated on the arm of the chair, leaning on the far armrest. This puts their faces in close proximity but at different heights. (A variation of this is to have the man seated and the woman standing. However, when

Marc Weisberg created this wonderfully intimate and happy portrait by having the couple face each other and embrace. The groom's hands hold his bride close to him and Marc tilted the camera just slightly to introduce a series of strong diagonal lines into the composition. The red background complements the brightly colored wedding clothes of the couple.

their heads are so far apart, you should pull back and make the portrait full-length.) When you seat the woman in an armchair, her hands should be in her lap and used to slim the body—waist, thighs, and hips. She should be seated at an angle and the foot of the leg farthest from the camera should be "hooked" behind the front leg—a pose that women seem to fall into naturally.

For as many examples as are given here, there are ten times as many variations. Study groups of two as there are some very dynamic ways to pose two people, only a handful of which are covered here.

The Bride Should Be Closest

When you have a choice—and the photographer always has a choice—position the bride closer to the camera than the groom. This keeps the (usually) smaller bride in proper perspective and allows her dress to be better shown.

ABOVE—*With the bride in front of the groom and her weight on her back foot, Michael O'Neill has created a beautiful lakeside portrait of the couple.*

Add a Third. A group portrait of three is still small and intimate. It lends itself to a pyramid- or diamond-shaped composition, or an inverted triangle, all of which are pleasing to the eye. (And don't simply adjust the height of the faces so that each is at a different level. Use the turn of the shoulders of those at either end of the group as a means of linking the group together.)

Once you add a third person, you will begin to notice the interplay of lines and shapes inherent in good group design. As an exercise, plot the implied line that goes through the shoulders or faces of the three people in the group. If the line is sharp or jagged, try adjusting the composition so that the line is more flowing, with gentler angles. Try a simple maneuver like turning the last or lowest person in the group inward toward the group and see what effect it has.

Still as part of the exercise, try a different configuration. For example, create a single diagonal line with the faces at different heights and all people in

> You will begin to notice the interplay of lines and shapes.

When you add a third person to the group, hands and legs start to become a problem.

the group touching. It's a simple yet very pleasing design. The power and serenity of a well-defined diagonal line in a composition can compel the viewer to keep looking at the portrait. Adjust the group again by having those at the ends of the diagonal tilt their heads slightly in toward the center person. It's a slight adjustment that can make a big difference in the overall design of the image.

How about trying the bird's-eye view? Cluster the group of three together, grab a stepladder or other high vantage point, and you've got a lovely variation on the three-person group.

When you add a third person to the group, hands and legs start to become a problem. One solution is to show only one arm and leg per person. This is sage advice; when the group is similarly dressed, as a wedding party is, one is not always sure whose hand belongs to whom. Generally, the outer hand should be visible, the inner hand, compositionally, can be easily hidden.

Adding a Fourth. With four subjects, things get interesting. You will find that as you photograph more group portraits even numbers of people are harder to pose than odd. Three, five, seven, or nine people are much easier to photograph than the even-numbered group of people. The reason is that the eye and brain tend to accept the disorder of odd-numbered objects more readily than even-numbered objects. According to Norman Phillips, even

Odd numbered groups are easier to photograph than even ones. Here, four people comprise the main group—all animated, having fun, and walking toward the camera. But wait, there is a rather homely fifth member of the group in a pink dress and also on a leash. The pooch gives the portrait a nice sense of asymmetry and adds just enough quirkiness to make this a truly memorable image. Photograph by Annika Metsla.

numbers don't work as well because they make diagonals too long and they leave an extra person to find space for in traditional triangular compositions. As you will see, the fourth member of a group can become an "extra wheel" if not handled properly.

With four people, you can simply add a person to the existing poses of three described above, with the following caveat. Be sure to keep the eye height of the fourth person different from any of the others in the group. Also, be aware that you are now forming shapes within your composition. Try to think in terms of pyramids, inverted triangles, diamonds and curved lines.

Keep in mind that the various body parts—for instance, the line up one arm, through the shoulders of several people, and down the arm of the person on the far side of the group—form an implied line that is just as important as the shapes you define with faces. Be aware of both line and shape, and direction, as you build your groups.

An excellent pose for four people is the sweeping curve of three people with the fourth person added below and between the first and second person in the group. Alternately, you might prefer to play off of the symmetry of the even number of people. Break the rules and seat two and stand two and, with heads close together, make the line of the eyes of the two people parallel with the eyes of the bottom two. It's different and it's unexpected.

From Five on Up. Remember that the composition will always look better if the base is wider than the top, so the next person added should elongate the bottom of the group.

With groups of five or more, you can also start to coax S shapes and Z shapes out of your compositions. They form the most pleasing shapes and will hold a viewer's eye within the borders of the print. Keep in mind that the diagonal line has a great deal of visual power in an image and is one of the most potent design tools at your disposal.

Always remember that the use of different levels creates a sense of visual interest and lets the viewer's eye bounce from one face to another (as long as there is a logical and pleasing flow to the

For smaller groups, an ordinary folding chair works exceptionally well. Because there are no arms to this chair, two of the men pose with one knee on the ground to keep them at approximately the same head height as the mother. The standing men lean forward a little to compact the group, but also to shrink the plane of focus, so that a relatively wide-open aperture provides adequate depth of field to keep the group sharp. Photograph by Ken Sklute.

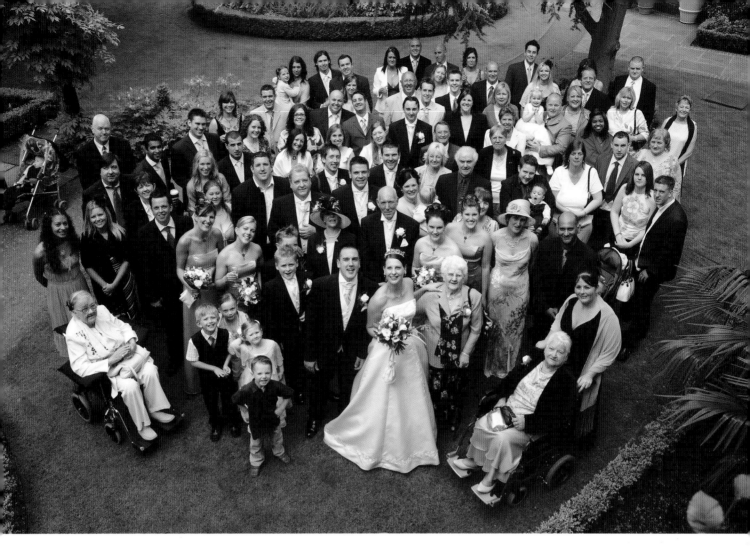

By elevating yourself above a large group like this and having them look up toward the camera, you can get everyone sharp and ensure you won't have any one group member blocking another. Dennis Orchard photographed this huge group with available light.

arrangement). The placement of faces, not bodies, dictates how pleasing and effective a composition will be.

When adding a sixth or an eighth person to the group, the group still must look asymmetrical for best effect. This is best accomplished by elongating sweeping lines and using the increased space to slot extra people.

As you add people to the group beyond six, you should start to base the shapes within the composition on linked shapes, like linked circles or triangles. What makes the combined shapes work is to turn them toward the center—the diamond shape of four on the left can be turned 20 degrees or less toward center, the diamond shape of four on the right (which may encompass the center person from the other group) can also be turned toward the center, unifying the group composition.

Building Bigger Groups

Once a group exceeds nine people, it is no longer a small group. The complexities of posing and lighting expand and, if you're not careful to stay in charge, chaos will reign. It is always best to have a game plan in mind with big groups. Fight the tendency to "line 'em up and shoot 'em." This is, after all, a portrait and not a team photo.

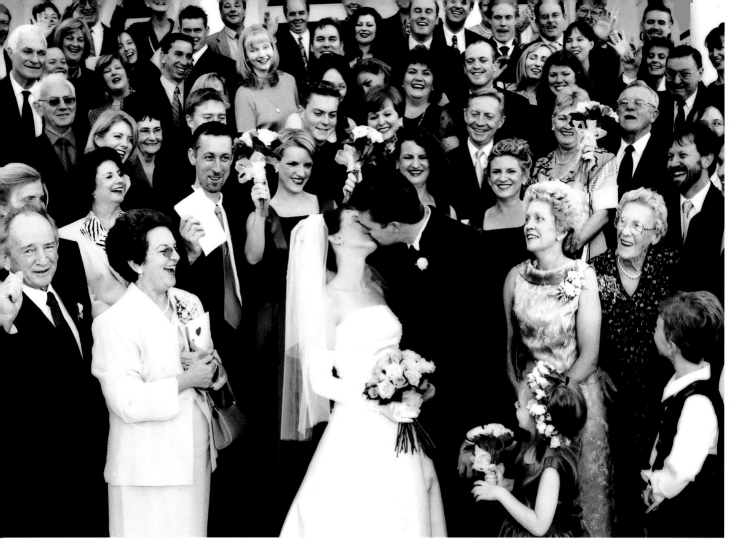

Posing bigger groups requires you to use standing poses, often combined with sitting and kneeling poses. Those in standing poses should be turned at least 20 degrees off center so that their shoulders are not parallel to the film plane. (The exception is with small children who gain better visual prominence when they are positioned square to the camera.) With standing poses, care must be taken to disguise wide hips and torsos. This can sometimes be accomplished simply by using other people in the group to block the camera's view of these problem areas.

When creating this type of portrait outdoors, some photographers prefer to place some extra space between group members to allow the background to become more integrated into the overall design of the image.

Building Really Big Groups

For really big groups it is a good idea to have the subjects stand close together—touching. This minimizes the space between people, allowing you to get a larger head size for each person in the group. One directive you must give to the group is that they must be able to see the camera with both eyes. This will ensure that you see all of their faces and that no one will be hiding behind the person in front of them.

Big groups are tricky. They need to be coordinated efficiently to keep the individual group members from being self-conscious or bored. Here, Marcus Bell used the couple kissing as a focal point for the group's concentration.

You will need help to persuade all the guests to pose for this photo. Make it sound fun—which it should be. The best man and ushers, as well as your assistant, can usually be persuaded to do the organizing. Have the guests put their drinks down before they enter the staging area, then try to coordinate the group so that everyone's face can be seen and the bride and groom are the center of interest.

Look for a high vantage point, such as a balcony or second-story window, from which you can make the portrait. You can even use a stepladder, but be sure someone holds it steady—particularly if you're at the very top. Use a wide-angle lens and focus about a third of the way into the group, using a moderate taking aperture to keep everyone sharply focused.

Technical Considerations

Keep the Camera Back Parallel to the Subject. With large groups, raising the camera height (angling the camera downward so that the film plane is more parallel to the plane of the group; see the diagram below) optimizes the plane of focus to accommodate the depth of the group. This makes it possible to get the front and back rows in focus at the same time. (The easiest way to achieve this angle is to shoot from a stepladder, which should be a permanent tool in your wedding arsenal. Be sure to have someone strong hold onto the ladder in case you lean the wrong way. Safety first!)

Shifting the Focus Field. Lenses characteristically focus objects in a more or less straight line—but not completely straight. If you line your subjects up in a straight line and back up so that you are far away from the group, all the subjects will be rendered sharply at almost any aperture. At a distance, how-

LEFT—Angling the camera downward helps ensure that the available depth of field covers all the subjects in the group. Diagram concept courtesy of Norman Phillips.

RIGHT—Subjects in the back of the group can lean in and subjects at the front of the group can lean back slightly so that all of your subjects fall within one plane. Diagram concept courtesy of Norman Phillips.

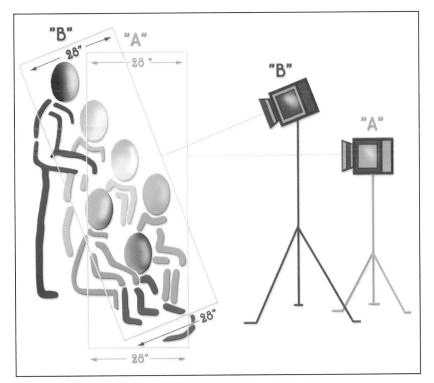

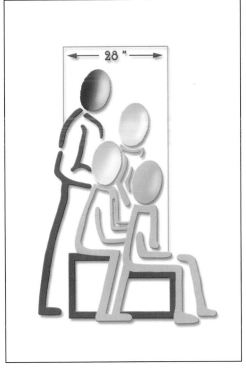

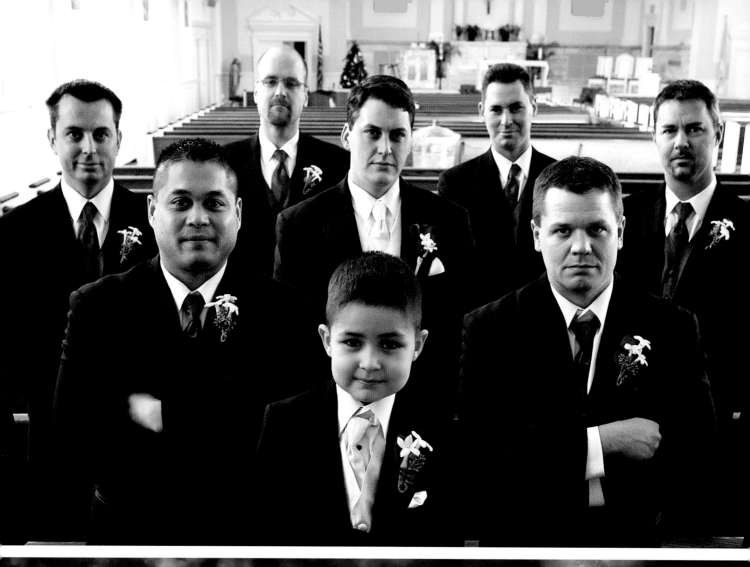
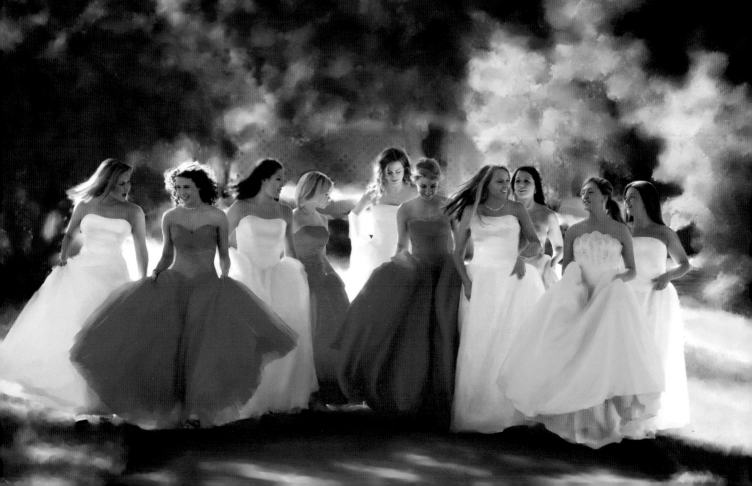

ABOVE—When a straight-line group is configured in front of the camera lens, the subjects directly in front of the camera will be closest to the lens. Those at the ends of the group will be a greater distance away from the lens. By "bowing" the group (having the centermost people take a step back and the outermost people take a step forward and everyone in between adjusting), all will be equidistant from the lens and focus will be a snap—even at wider apertures. Diagram concept courtesy of Norman Phillips.

FACING PAGE, TOP—With the camera raised to a higher level, the photographer is able to make the most of the available depth of field at any given aperture. Here, the photographer also split the focus between the first and third rows of the group. When you focus halfway into your subject, your depth of field extends both in front of and behind the point of focus. Photograph by Michael O'Neill.

FACING PAGE, BOTTOM—If you notice the planes of focus in this group, the bride is about three feet behind the forward-most bridesmaids on either end of the group. This concept is called "bowing" the group and allows all of the group members to be at pretty much the same distance from the lens. Photograph by John Ratchford.

ever, the subjects are small in the frame. For a better image, you must move closer to the group, making those at the ends of the group proportionately farther away from the lens than those in the middle of the lineup. Those farthest from the lens will be difficult to keep in focus. The solution is to bend the group, having the middle of the group step back and the ends of the group step forward so that all of the people in the group are the same relative distance from the camera (see the diagram above). To the camera, the group looks like a straight line, but you have actually distorted the plane of sharpness to accommodate the group.

A Final Check

One of the biggest flaws a photographer can make in an image is a background element that seemingly "sprouts" from one of the subjects. The classic telephone pole comes to mind.

While this is an amateur mistake for the most part, the truth is that I see an amazing number of images from proven and sometimes award-winning pros that make this same mistake. The problem is that the photographer failed to do a final perimeter check. This is where you scan the group's silhouette, making sure there's nothing in the background that you missed. Pay particular attention to strong verticals, like light-colored posts or columns, and also to diagonals. Even though these elements may be out of focus, if they are tonally dominant they will disrupt and often ruin an otherwise beautiful composition.

One way to control your backgrounds more effectively is to scout the venues you want to use before you show up for the big day. Check the light at the same approximate time of day that your wedding party will be there and be prepared for what the changing light might do to your background an hour or two later.

Once your group is composed (especially when working with larger groups), you should also do a once-around-the-frame analysis, making sure the poses, lighting, and expressions are good and that nothing needs adjusting. Check the negative space around each person, as well, scanning the perimeter of each person to look for obvious flaws and any refinements you could quickly make. Now is the time to analyze your image, not after you've

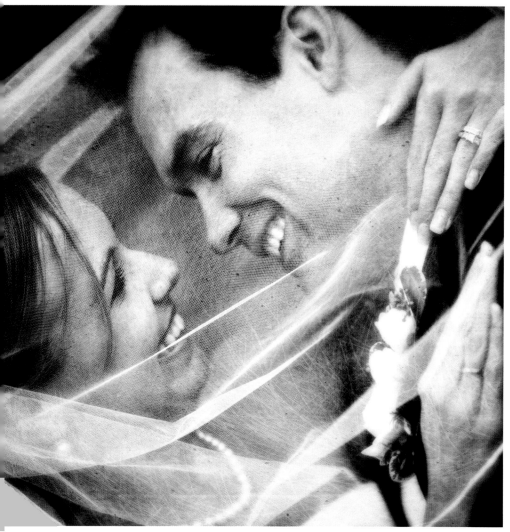

TOP—This is one of my favorite group portraits, because it is thoroughly enjoyable on a number of levels. It's a walking portrait with seven bridesmaids and eight pillars—and symmetry *vs.* asymmetry is a stimulant. More to the point, the girls are all having fun and their poses, with all of the curves and swirls of their dresses, sharply contrast the rigid grid-work of windowpanes and straight vertical lines of the pillars. Photograph by Tom Muñoz.

BOTTOM—One method of active posing, the subject of our next chapter, is to give the subjects some general directions that involve movement. The photographer then stays close and "works" the image. Such was the case here, with this wonderfully animated close-up of the bride and groom made by JB Sallee.

made four or five frames. Learn to check the viewfinder quickly. Two quick scans is really all it takes. You can also make a quick exposure and review the image on the camera's LCD. This will freeze the image and allow you to inspect each quadrant for focus, expression, and posing. Do it quickly, however, as you don't want to delay things unnecessarily.

6. Spontaneity in Posing

S ome of the finest portraits are those made without the subject being aware of the camera. This style of portraiture is based on the images made popular by contemporary wedding photojournalists. The objective is to let the scene tell the story, recording a delicate slice of life that captures the greater meaning of the events shown in the lives of those pictured.

Active Posing

One of the recent trends in portraiture is what is called "active posing," which is a sort of stop-action glamour posing—isolating the pose from within a flowing movement. This type of posing is useful in photographing trained models, but can also be fun to use with untrained subjects like brides, who can be easily coaxed into moving quite well in front of the camera. Playing music often helps to set the mood, as does keeping the energy level of the session high.

Subtle Direction

While the pure wedding photojournalist does not intrude on the scene, it is sometimes necessary to inject a bit of "direction." I am reminded of a story related by Dennis Orchard, a well-known wedding photographer from the U.K. He observed a mother embracing her two sons at a wedding—and it was a priceless moment. By the time Dennis got up on a chair to capture it, though, the shot had disappeared. He called over to the mom and said, "How

> The objective is to let the scene tell the story.

Spontaneous portraits will happen most frequently when the photographer works quietly and unobserved. Here, while the subjects may have known that photographer Nick Adams was only a few feet away, they reacted spontaneously.

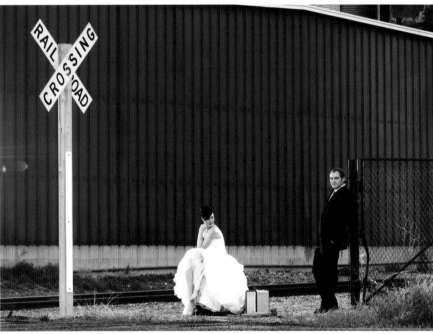

TOP—Active posing has become very popular. For the photographer, it's like photographing action, so one must go for the peak of action and generally fire off images with a high burst rate in continuous mode. Joe Photo combined a leisurely ride for the bride with a special effects border for a memorable image.

BOTTOM—This is the kind of image that requires some direction and staging in order for the subjects to know the intent of the photograph. Nick Adams likes to shoot a separate bridal session (not on the wedding day) so that the bride and groom are relaxed and not worried about time away from other things. This portrait is more like a fashion shoot, in which the subjects are models.

about another hug?" Since the emotion was still fresh, she complied and Orchard got an award-winning shot (seen at the top of the facing page).

Staging Tips from Marcus Bell

Marcus Bell, an Australian wedding and portrait photographer, is never in a rush to take his portraits— whether he's in the studio or at a wedding. He uses his ability to relate to people and put them at ease to infuse his personality into the session. In this way, he leaves nothing to chance, but also lets his subjects define their own poses. He says, "I want to capture the true individuality and personality of the person. The posing needs to be natural to the person you're photographing and to reflect the person's personality or features

He leaves nothing to chance, but also lets his subjects define their own poses.

and not detract from them. I use several techniques to ensure the posing relates to the subject, but to do this you first need to do your groundwork and include your subject in your preparations."

Bell uses a number of techniques to begin the interaction—having a coffee, walking to the shooting location, etc.—in order to provide ample opportunity to talk and get the relationship established. "Where possible," he says, "I want to minimize the direction that I'm giving them and to allow

Bell uses a number of techniques to begin the interaction . . .

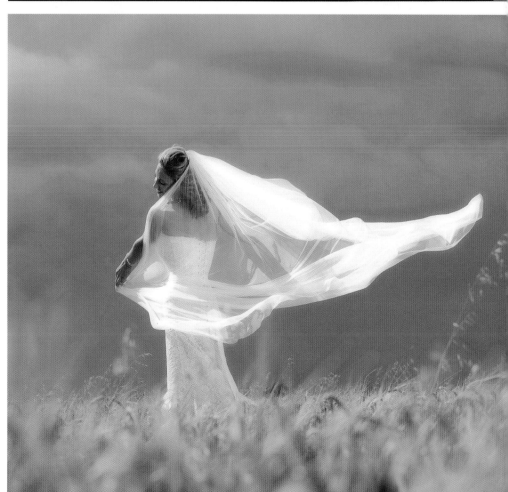

TOP—This mother had just given her two boys a fierce hug. To capture the missed moment, Dennis Orchard quickly grabbed a chair to get above the crowd, and said "How about another hug?" She complied, grabbed the boys, and Orchard re-created the moment.

BOTTOM—Almost every one of Annika Metsla's bridal portraits looks spontaneous. Crouching low in the grass, Annika provided some very general posing suggestions then fired away. The low vantage point provided depth in the photo, making it look like an isolated scene. The lighting in this image is superb, with subtle back-lighting balanced with natural fill from the wedding dress and some very weak flash fill used to the right of the camera. Notice how the swirling whiteness of the veil contrasts nicely with the rich gray sky.

them to be themselves. Because of the relationship and trust that we have started, though, I can give them directions to pose in a way that appears to the subject to be more like normal conversation rather than them feeling I'm just telling them what to do. They also start feeling more involved in the whole process."

Bell first observes the bride, making mental notes of what he'd like to see. Then, if he can't replicate the nuance, he'll ask the bride to do what he saw.

Marcus Bell captured the serene beauty of the location and the bride in a single shot. You can see that she is caught perfectly in mid-stride, as if strolling on a cloud.

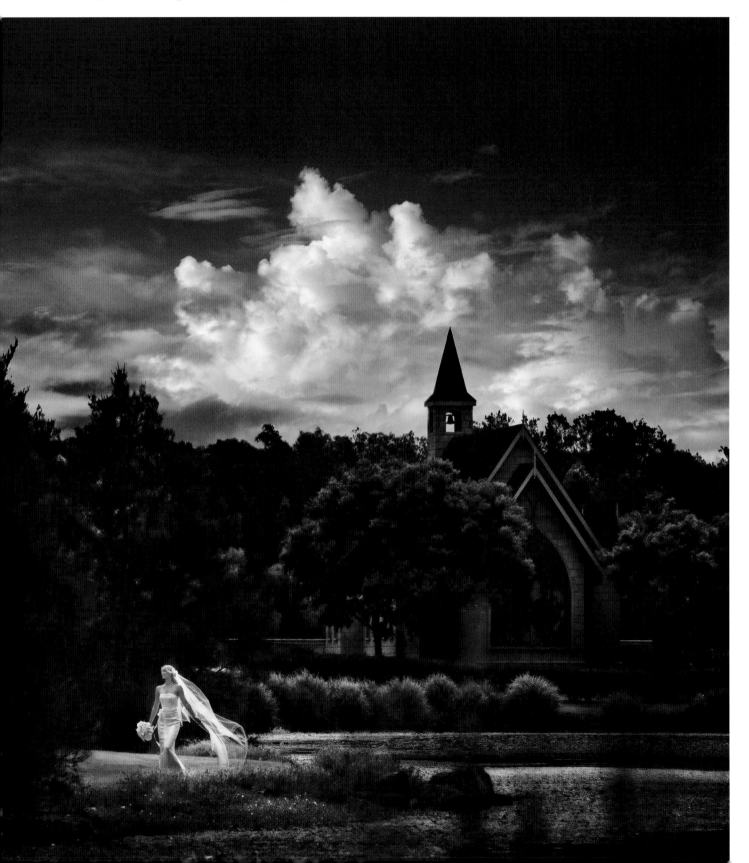

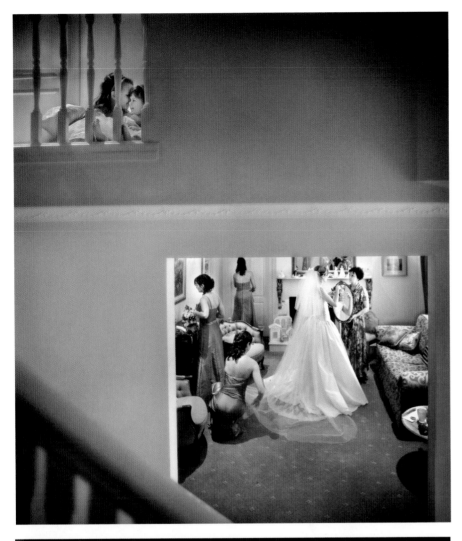

TOP—There is no posing here at all. It is strictly a result of the photographer's keen powers of observation. It's included here to show the world-class photojournalistic skills of the photographer and the concentration with which he goes about his job. Marcus Bell, the photographer, is a great observer. This scene may have gone unnoticed by another top photographer. This was an grand award-winning print at WPPI.

BOTTOM—One reason why Marcus Bell spends so much time in advance of the actual wedding getting to know the bride and groom is so they will treat him like not like a guest or visitor, but as part of the family. This fascinating scene has at least three stories happening simultaneously. Patience and observation are the keys to his overwhelming success as a wedding photographer.

For instance, on one occasion he observed the bride walking with her head down, which is in itself a charming pose, but she then looked up and smiled at just the right moment. Marcus had her walk some some, trying to re-create the moment, but she didn't look up. So he simply prompted her to glance up while walking—all without making her self-conscious. He will keep the flow going in these situations but is constantly observing the nuances that occur naturally. These are the opportunities that make great pictures.

Bell also uses the large LCD screens of his digital cameras as social and posing prompts, showing his clients between shots what's going on and offering friendly ways to improve on their poses. He will often take an image of the scene, showing them images even before he has included them in the scene. According to Marcus, "This builds rapport, trust, and unity as you have their cooperation and enthusiasm."

Award-winning Australian photographer Jerry Ghionis does not pose his clients, he "prompts" them. "I prompt them to create situations that appear natural," he says. He first chooses the lighting, selects the background and foreground, and then directs his clients into a "rough" pose—a romantic hug, a casual walk, the bride adjusting her veil, and so forth. The spontaneous moments he gets are directed and seem to evolve during the shoot, depending on what suits the different personalities he is working with.

A technique Jerry relies on is the "wouldn't it be great" principle. For example, he might think to himself, "Wouldn't it be great if the bride cracked up laughing, with her eyes closed and the groom leaning towards her?" He

Sometimes Jerry Ghionis relies on his incredible timing and reflexes to capture a great image.

ABOVE—Jerry Ghionis brings an element of high fashion to his bridals. In this elegant image, the gown and bride are lit and posed to create the height of fashion and beauty. Note the beautiful diamond shape created by the bend of her arms, and the subtle S-curve that runs through her body. Her gaze is toward the light, which is both functional and effective artistically.

RIGHT—Images by Jerry Ghionis often tell a story, as this one does. The light and pose are both elegant and the props and furniture are extremely interesting visually, which is why they are included prominently in the image. The stoic impression of the figure in black contrasts with the look of enlightened indifference on the bride's face. It's an award-winning image.

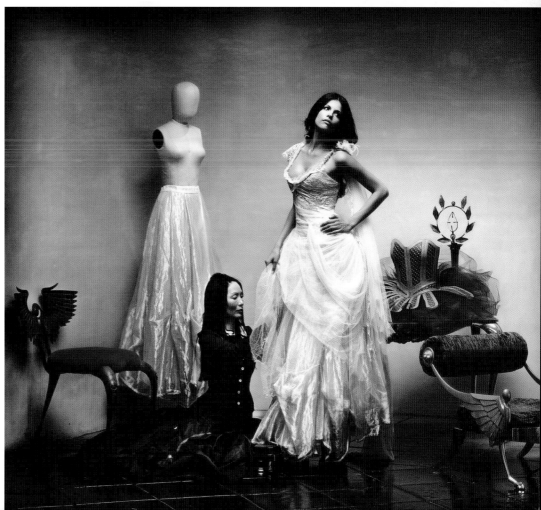

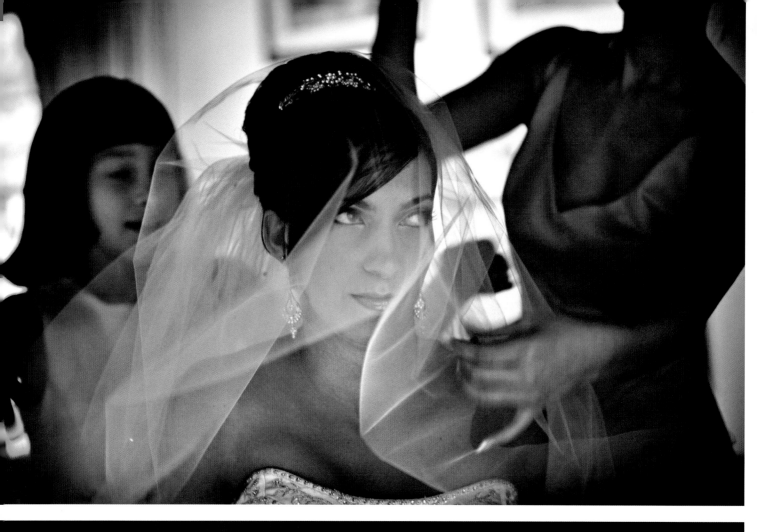

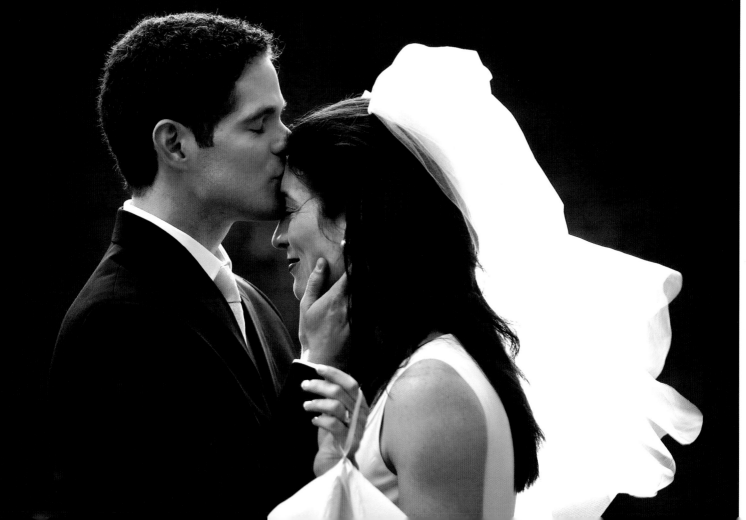

FACING PAGE, TOP—Even though Greg Gibson may be very close to the subjects, they never seem to be aware of him and he always manages to bring an interesting story out of the scene.

FACING PAGE, BOTTOM—Greg Gibson won't spend a lot of time posing pictures, as his roots are purely photojournalistic. However, he will offer some minor suggestions as to subject positioning and then go on from there.

BELOW—This is a simple but elegant close-up formal by Tom Muñoz. Note some of the fine points: the background is softened so that it is a canvas of pastel colors; the head and neck axes are great; the arms are extended out from the body, slimming them and narrowing the bodice; and finally, the head is tipped toward the near shoulder in the traditional "feminine pose."

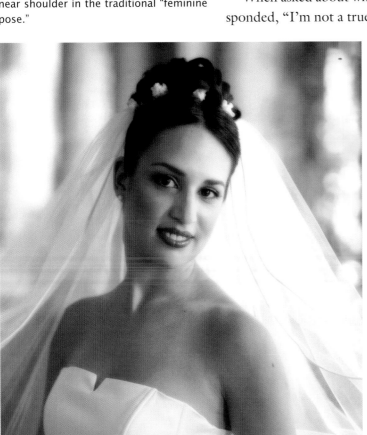

then asked the question out loud, prompting them to enact the "what if." Jerry thinks this is no more manufactured than a scene in a movie. "Who cares how you got there—the end justifies the means," he says.

Greg Gibson is Not Quite a Fly on the Wall

In the first half of his career, Greg Gibson was an award-winning photojournalist—in fact, he's a two-time Pulitzer Prize winner. Now, he's an award-winning wedding photographer. He respects the role of the wedding photojournalist but is not trapped by the definition. He says, "My clients are professional people. They want to enjoy their day and not be encumbered by posing for pictures. They want to record the day, the real feelings they share with their friends and family members. My experience gives my work instant credibility. I try to take advantage of the resources at a wedding. If a bride is getting dressed in an area with bad light I may say, 'Can we come over here and do this?' However, I don't try to create moments or impose something on their day by saying, 'Let me get you and your mother hugging.' I try to let those things happen spontaneously and use my background and experience to put myself in the right position to anticipate those moments."

When asked about what kind of wedding photojournalist he is, Gibson responded, "I'm not a true fly on the wall. I interact with the client. There are two camps of photojournalists—ones who want to be totally invisible, they don't talk or interact. I'm definitely in the other camp. I laugh and joke with the client, get them to relax with my presence. We're going to spend a lot of time together and I don't want them to feel like there's a stranger in the room. If I find myself constantly in conversations with the bride and family members, then I withdraw a bit. I don't want to be talking and not taking photos."

Tom Muñoz Has Respect for Tradition

In 1909, a Muñoz opened a small photography studio in Cuba. Now, a century later, the Muñoz family still takes pride in their photographic history. Fathers taught sons and grandfathers taught grandsons the skill that it took to be known as a Muñoz photographer.

Twenty-something Tom Muñoz is a master wedding photographer who photographed his first full wedding alone at the age of twelve—even though he had to have the couple drive him everywhere as he had "no ride." As a fourth-generation photographer with six independently owned Muñoz

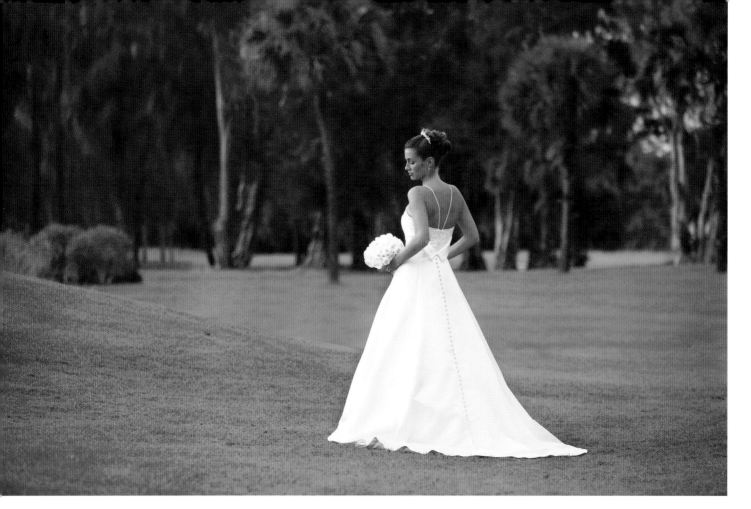

studios in the South Florida area, where he works, Tom has been through the wedding photojournalistic phase and, while a practitioner, believes that clients also want the formality of yesterday in their images. For instance, with film, Muñoz shot everything at f/8 using a flash to ensure he got the shots. Today, he uses available light for the first 300–400 pictures he takes. "With film," he says, "we used more flash because we were afraid of movement and lack of focus. Now I'm photographing with an f/1.2 lens and shooting portraits at f/1.6. Before, that was unheard of." In the past, Muñoz' style was also more posed, but with digital he made a strong push toward photojournalism. "Now," he says, "there's been a shift back toward the more traditional look."

Tom has a great deal of respect for the bride and for the wedding as an event. "When we're photographing the bride, we treat her like she's a princess. There are no unattractive brides," Muñoz says sincerely. Besides knowing how to pose a woman, one of the biggest things that changes her posture and expression is what you tell her. "We're not dealing with models," Muñoz stresses. "As stupid as it sounds, telling a bride how beautiful she looks changes how she photographs and how she perceives being photographed. It becomes a positive experience rather than a time-consuming, annoying one. Same thing goes for the groom," Tom states. "His chest pumps up, he arches his back; they fall right into it. It's very cute."

Tom Muñoz knows his stuff. In late afternoon light, he fashioned a beautifully edge-lit profile pose in a perfect location. Notice the fine points of the pose: the elbows are extended by bringing the bouquet to the waist; the head is tilted toward the near shoulder, reinforcing the "feminine" pose; the gown is flawless and provides a beautiful triangular base to the composition.

7. Posing and the Must-Have Shots

At every wedding, there are some key events that the bride and groom will expect to see documented in their images. Including these is important for creating an album that tells the whole story of the couple's special day. The following are a few tips on what to shoot and some ideas for making the most of each moment as it happens. Not all of these shots are included in every wedding. Religious customs and regional differences in weddings often produce unique elements to the wedding that may not be included here.

At the Bride's House

Typically, wedding-day coverage begins with the bride getting ready. Find out what time you may arrive (ideally, about an hour before the bride leaves for the church) and be there a little early. You may have to wait a bit—there are a million details for the bride and her helpers to attend to—but don't just stand around. Instead, look for opportunities to create still lifes or family shots. You may even suggest that the bride's family arrange for the flowers to be delivered early and use the time to set up an attractive still life for the album while you wait.

When you get the okay to enter the bride's room, realize that it may be tense in there. Try to blend in and observe. Look for shots as they present themselves, particularly with the mother and daughter or the bridesmaids.

The more people that are involved in the bride's preparations before the wedding, the more chaos—and also the more fabulous moments—will unfold before your camera. Photograph by Marcus Bell.

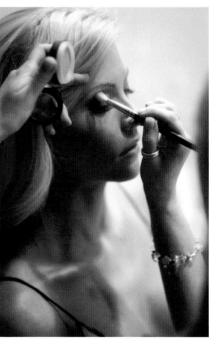

The Groom

You do, of course, want to photograph the groom before the wedding. Some grooms are nervous, others are gregarious—like it's any other day. Regardless, there are ample picture opportunities before anyone else arrives. It's also a great opportunity to do formal portraits of the groom, the groom and his dad, and the groom and his best man. A three-quarter-length portrait is a good choice—and you can include the architecture of the venue to really set the scene. When photographing men, always check that the ties are properly knotted. If they are wearing vests, make sure that they are correctly buttoned

and that the bottom button is undone. Study the wedding magazines and latest gentlemen's magazines to brush up on poses. Often the groom and his attendants are posed very casually, but the groom should always be central to the composition.

The Ceremony

The first step when photographing a wedding is to learn the policies of the venue. At some churches you may be able to move around freely, at others you may only be able to take photographs from the back, in still others you may be offered the chance to go into a gallery or the balcony. You should also be prepared for the possibility that you may not be able to make pictures at all during the ceremony.

Whatever photography policies the church may dictate, you must be discrete during the ceremony. Nobody wants to hear the "ca-chunk" of the camera's shutter or see a blinding flash as the couple exchange their vows. It's better by far to work from a distance with a tripod- or monopod-mounted DSLR, and to work by available light, which will provide a more intimate feeling to the images. Work quietly and unobserved—in short, be invisible.

Some of the events you will need to cover are: the bridesmaids and flower girls entering the church; the bride entering the church; the parents being

Greg Gibson chose the moment when the bride and groom faced the assembled group for the first time as man and wife to make this beautiful available-light image. He used the strong backlighting of the church's stained glass windows and chose not to fill the image, allowing the beautiful crisp light to rim-light the couple.

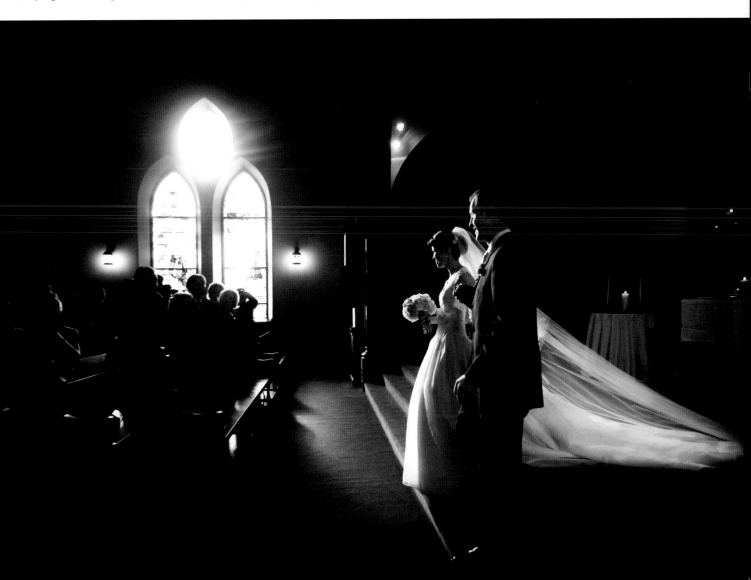

escorted in; the bride's dad "giving her away;" the first time the bride and groom meet at the altar; the minister or priest talking with them; the ring exchange; the exchange of vows; the kiss; the bride and groom turning to face the assembly; the bride and groom coming up the aisle; and any number of two dozen variations—plus all the surprises along the way.

Note that this scenario applies only to a Christian wedding. Every religion has its own customs and traditions that you need to be thoroughly familiar with before the wedding.

Family Groups

Regardless of your style of coverage, family groups are pictures that will be desired by all. You must find time to make the requisite group shots, but also be aware of shots that the bride may not have requested, but expects to see. For example, the bride with her new parents and the groom with his are great shots, but are not ones that will necessarily be "on the list."

This is where your group posing expertise will be taxed to the limit—you'll need to work very quickly. If there are too many "must" shots to do in a short time, consider making them at the church door as the couple and bridal party emerge. Everyone in the wedding party is present and the parents are nearby.

Charles Maring is exceptionally good at getting perfectly posed formal family groups. Here is a formal of the bride, family, and the wedding party—all on two pages of the wedding album.

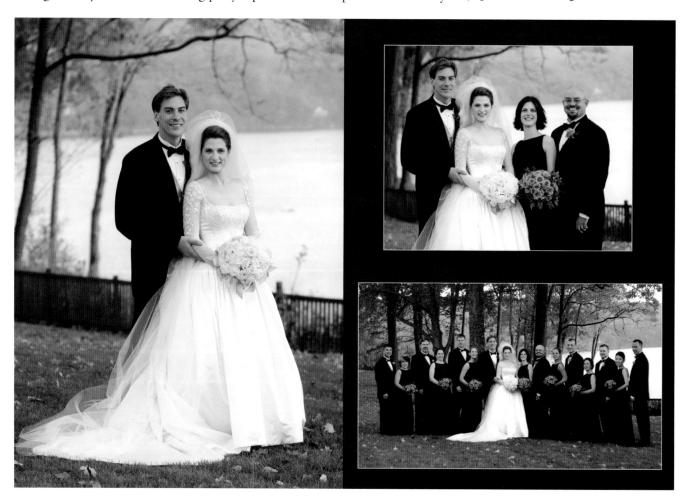

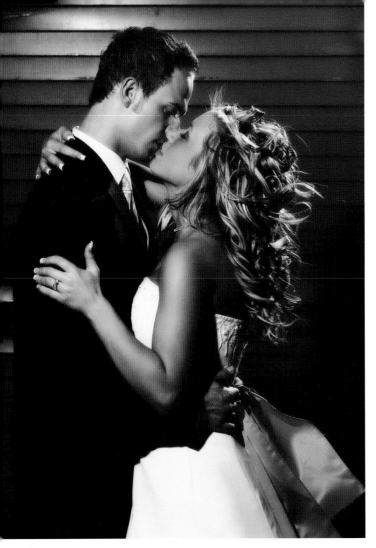

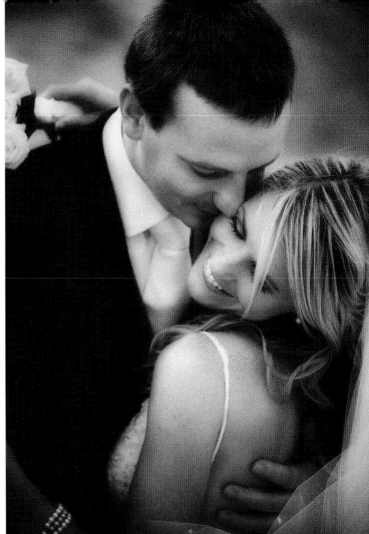

LEFT—According to most brides, photographers don't get enough shots of the bride and groom kissing. Make it a priority. Note here, that they are not actually kissing, but about to kiss—which is much better photographically, because their features are not, for lack of a better word, squished. Photograph by Nick Adams.

RIGHT—There are never enough intimate moments between the bride and groom, so make it a priority to shoot some—especially when they are kissing. Photograph by Mark Nixon.

You can also make these portraits at the reception if need be. All of this should, of course, be thought out beforehand.

Portraits of the Bride and Groom

Following the ceremony, you should be able to steal the bride and groom for a brief time. Limit yourself to ten minutes, or you will be taking too much of their time and the others in attendance will get a little edgy. (If the light or the location are not good, you can also wait and make the formals at the reception, where you can usually find a beautiful hotel lobby or outdoor garden to use as the setting.)

These will be some of the key images you create during the day, so they must be special. Make at least two formal portraits, a full-length shot and a three-quarter-length portrait. Position the bride in front of the groom so you can see her dress (and make sure the bouquet is visible). Then, have the groom place his arm around his bride but with his hand in the middle of her back. Finally, ask them to lean in toward each other with their weight on their back feet and a slight bend to their forward knees. Quick and easy.

Whether you set it up, which you may have to do, or wait for it to occur naturally, be sure to get the bride and groom kissing at least once. These are

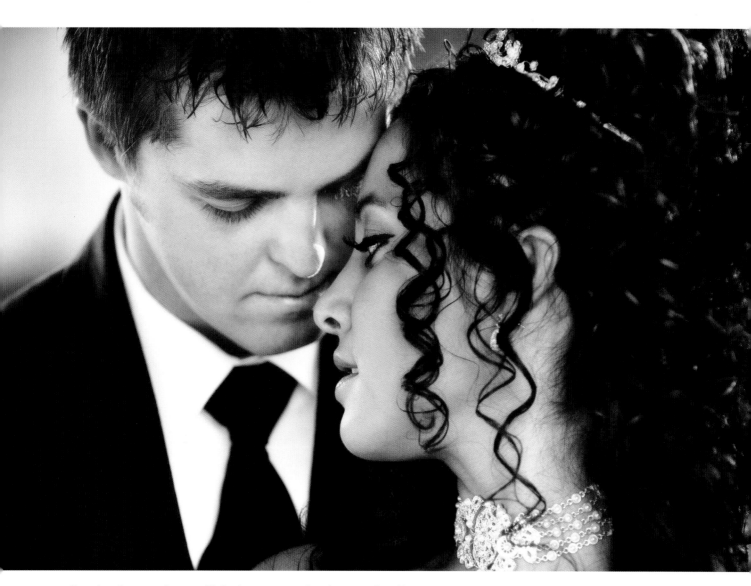

favorite shots and you will find many uses for them in the album. For the best results, get a good vantage point and make sure you adjust your camera angle so neither person obscures the other. Often when making the formal portrait of the bride and groom, this is a good time to get a few kissing shots.

Formals of the Bride

To display the dress beautifully, the bride must stand well. Although you may only be taking a three-quarter-length or head-and-shoulders portrait, start the pose at the feet. When you arrange the bride's feet with one foot forward of the other, the shoulders will naturally be at their most flattering, one higher than the other. Have her stand at an angle to the lens, with her weight on her back foot and her front knee slightly bent. The most feminine position for her head is to have it turned and tilted toward the higher shoulder. This places the entire body in an attractive S-curve—a classic bridal pose.

Have the bride hold her bouquet in the hand on the same side of her body as the foot that is extended. If the bouquet is held in the left hand, the right

This is a beautifully posed and executed bridal formal close-up by Nick Adams. One must remember that the bride and groom will probably never look better at any time in their lives. Even though the image was shot at f/2.8 and at close quarters, Nick split the focus between them so that both the bride's and groom's eyes are sharp.

arm should come in to meet the other at wrist level. She should hold her bouquet a bit below waist level to show off the waistline of the dress, which is an important part of the dress design.

Take plenty of photographs of the bride to show the dress from all angles, being sure to include the train and veil in at least several of the shots. (*Note:* Ask the maid of honor to help with the dress, which often has a mind of its own. Her presence also offers reassurance to the bride.)

> Take plenty of photographs of the bride to show the dress from all angles.

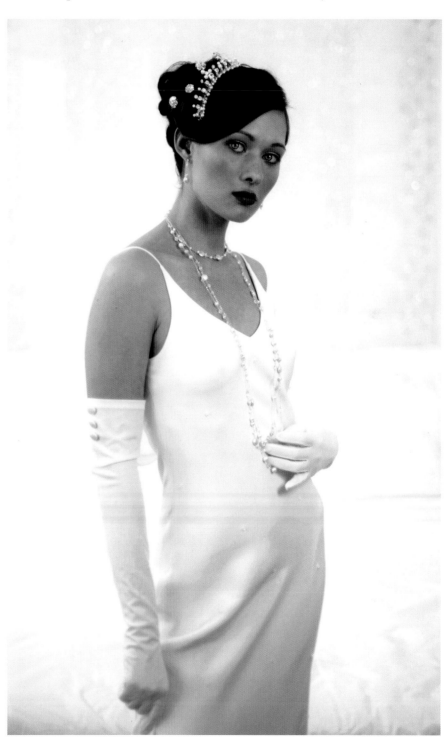

When making a bridal portrait, it is imperative to not only show off the beauty of the bride but also the beauty of the wedding gown. Mike Colón created this beautiful high-key, three-quarter-length portrait of the bride. Note the delicate pose of the hand, the turn of the body, the weight on her back foot, the separation of the near arm from the torso—and last but not least, the delicate detail in the dress, despite the fact that the image is high key. It was made in a bedroom before the ceremony with available light and a silver reflector for fill.

ABOVE—This picture by Emin Kuliyev is one of my favorite wedding pictures of all time. The bride and groom leap for joy in the middle of a busy New York City street, as if they are the center of the universe at this moment. There is no need to see their faces, or the brocade of the wedding gown, or the cut of the groom's tux, or even their faces—there is only this leap of joy!

TOP LEFT—The formals don't always have to be formal. For instance, this small group of bridesmaids is photographed in complete hilarity. It will work for the album as well as make everyone remember an enjoyable moment and an enjoyable day. Notice the tight cropping, with the bridesmaids facing toward the bride. Photograph by Mark Nixon.

BOTTOM LEFT—This is a most unusual portrait of the bride and the groomsmen by Jesh deRox. The bride is stunning and extremely relaxed and also extremely well lit, thanks to a small video light feathered so the transition from highlight to shadow is perfectly smooth. The groomsmen are arranged asymmetrically around the bride in a seemingly random configuration, but their positions in the frame all seem to draw your eye in toward the bride, the intent of the image.

Even when carefully choreographed beforehand, the rice toss (or bubbles, or confetti) as the bride and groom are leaving the church makes a good shot. Here, Dan Doke balanced the daylight exposure with his on-camera flash for a perfect exposure that freezes the bride and groom but not the rice. The shutter speed used was $\frac{1}{125}$ second.

The Wedding Party

This is one "formal" group that does not have to be formal. I have seen wedding party portraits with the bride, groom, bridesmaids, and groomsmen doing a conga line down the beach, dresses held high out of the water and the men's pant legs rolled up. And I have seen elegant, formal pyramid arrangements, where every bouquet and every pose is identical and beautiful. It all depends on your client and your tastes. Most opt for boy–girl arrangements, with the bride and groom somewhere central in the image. As with the bridal portrait, the bridesmaids should be in front of the groomsmen in order to highlight their dresses.

Leaving the Church

You can alert guests to get ready and "release" on your count.

Predetermine the composition and exposure and be ready and waiting as the couple exits the church. If guests are throwing confetti or rice, don't be afraid to choreograph the event in advance. You can alert guests to get ready and "release" on your count. Using a slow ($\frac{1}{30}$ to $\frac{1}{125}$ second) shutter speed and flash, you will freeze the couple and the rice, but the moving objects will have a blurred edge. If you'd rather just let it happen, do a burst sequence at the camera's fastest flash-sync speed and with a wide-angle-to-short-telephoto zoom. Be alert for the unexpected, and consider having a second shooter also cover events like this to better your odds of getting the key picture.

Venue Shots at the Reception

Whenever possible, try to make a photograph of the reception site before the guests arrive. Photograph one table in the foreground and be sure to include the floral and lighting effects. Also, photograph a single place setting and a few other details. The bride will love them, and you'll find use for them in the album design. The caterers and other vendors will also appreciate a print that reflects their fine efforts. Some photographers try to include the bride and groom in the scene, which can be tricky. Their presence does, however, add to the shot. Before the guests enter the reception area, for instance, Ken Sklute often photographs the bride and groom dancing slowly in the background and it is a nice touch.

Great overall shots of the reception not only provide much needed scene-setters in the album, they can also be good public relations tools for your business. If you send prints to the caterer and hotel banquet manager, they will likely recommend you to prospective brides. Photograph by Dan Doke.

The Reception

The reception calls upon all of your skills and instincts. Things happen quickly, so don't get caught with an important event coming up and only two frames left on your CF card! Fast zooms and fast telephoto lenses paired with fast film or high ISO settings will give you the best chance to work unobserved. Often, the reception is best lit with a number of corner-mounted umbrellas, triggered by your on-camera flash or radio remote. That way, anything within

the perimeter of your lights can be photographed by strobe. Be certain you meter various areas within your lighting perimeter so that you know what your exposure is everywhere on the floor.

The reception is all about the couple and guests having a great time, so be cautious about intruding upon events. Try to observe the flow of the reception and anticipate the individual events before they happen. As the reception goes on and guests relax, the opportunities for great pictures will increase. Be sure to remain aware of the bride and groom all the time, as well; after all, they are the central players.

Be prepared for the scheduled events at the reception—the bouquet toss, removing the garter, the toasts, the first dance, and so on. If you have done

TOP—As the couple entered the reception through an arch of sparklers, Jeff Hawkins fired off a few frames with fill-flash balanced to the available light from the sparklers. One doesn't often know how these shots will turn out, so it is best to shoot a lot and hope for the best.

BOTTOM—You have to be on your toes for those wonderful moments that happen at all wedding receptions. This one was caught by two-time Pulitzer Prize winner Greg Gibson.

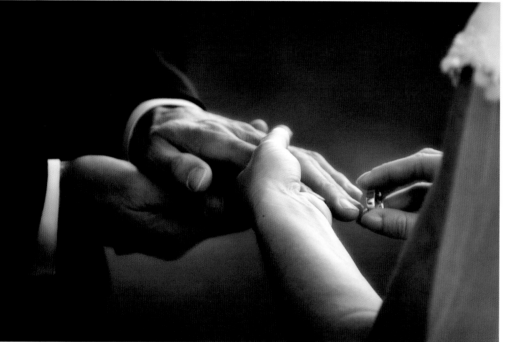

ABOVE—A beautiful still life of the wedding cake (or, in this case, the wedding cakes) is a good idea for several reasons. With cakes costing as much as they do today, it's a great way to tie your business to that of the baker, who may do countless high-end weddings. Also, they appreciate a nice photograph of their work. The bride and the bride's family also appreciate the natural beauty of the cakes. Today, this shot often replaces the traditional cake-cutting shot in the album. Photograph by Cherie Steinberg Coté.

TOP LEFT—Joe Buissink made this beautiful close-up of the rings by using a striped piece of fabric as a background. The yellow stripes, not dissimilar from the yellow stripes on a highway, lead your eye to the small treasures. Even though the strip of depth of field looks incredibly shallow, the aperture of f/5.0 was needed to keep the rings sharp at this close-up magnification.

BOTTOM LEFT—The ring exchange during the wedding ceremony is difficult to capture. Having two shooters helps, but even then you might get blocked out by the bride, groom, or minister. This is a good one indeed. Photograph by Nick Adams.

your homework, you will know where and when each of these events will take place, and you will have prepared to light it and photograph it. You should also coordinate your efforts with the person in charge, usually the wedding planner or banquet manager. He or she can run interference for you, as well as cue you when certain events are about to occur, often not letting the event begin until you are ready.

I have watched Joe Photo work a reception and it is an amazing sight. He often uses his Nikon D2X and flash in bounce mode and works quickly and quietly. His Nikon Speedlite is outfitted with a small forward-facing internal reflector that redirects some of the bounce flash directly onto his subject, making the flash both main and fill light at once. If he is observed and noticed, he'll often walk over and show the principals the image on the LCD,

offer some thoughtful compliment about how good they all look, and quickly move on. Other times he just shoots, observes, and shoots some more. His intensity and concentration at the reception are keen and he comes away with priceless images—the rewards of good work habits.

The Rings

The bride and groom usually love their new rings and want a shot of them. A close-up of the couple's hands displaying the rings makes a great detail image in the album. You can use any type of attractive pose, but remember that hands are difficult to pose. If you want a really close-up image of the rings, you will also need a macro lens, and you will probably have to light the scene with flash—unless you make the shot outdoors or in good light.

The Cake Cutting

Cakes have gotten incredibly expensive—some are over $10,000! For this reason, a stand-alone portrait of the cake is a good idea, both for the cake-maker and for the bride and groom. Be sure, also, to document the cake cutting (and any antics that may ensue).

The First Dance

When documenting the first dance, one trick you can use is to tell the couple beforehand, "Look at me and smile." That will keep you from having to circle the couple on the dance floor until you get both of them looking at you for the "first dance" shot. Or you can tell them, "Just look at each other and

The first dance is a must-have shot that should be part of every album. Here, Mike Colón used the ambient light of the ballroom and stage lighting to highlight the bride and groom. You sometimes have to work at getting either the bride or the groom facing the direction of the camera as often they are only looking at each other.

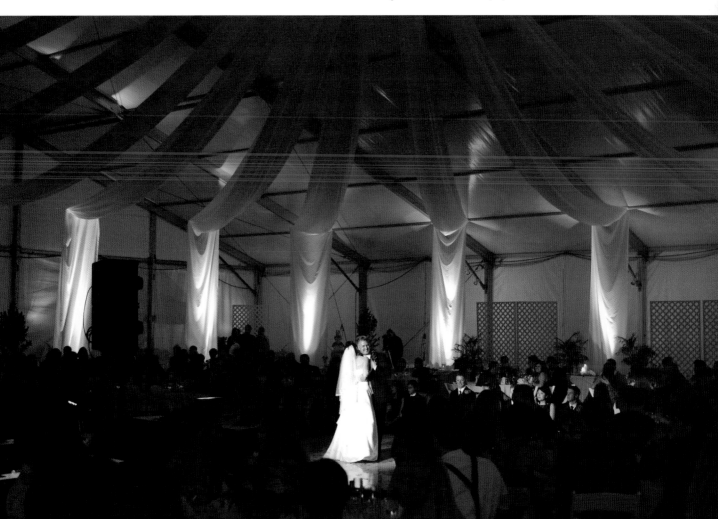

don't worry about me, I'll get the shot."

Often, photographers will photograph the first dance using the available light (often spotlights) on the dance floor. This is possible with fast lenses and fast ISOs. Just as frequently, the photographer will use flash and a slow shutter speed to record the ambient light in the room and the surrounding faces watching the couple's first dance. The flash will freeze the couple but there is often some blurring due to the slow shutter speed needed to capture the people only lit by ambient light.

The Bouquet Toss

The bouquet toss is one of the more memorable shots at any wedding reception. Whether you're a photojournalist or traditionalist, this shot looks best when it's spontaneous. You need plenty of depth of field, which almost dictates a wide-angle lens. You'll want to show not only the bride but also the expectant faces in the background. Although you can use available light, the shot is usually best done with two flashes—one on the bride and one on the ladies waiting for the bouquet. Your timing has to be excellent, as the bride will often "fake out" the group just for laughs. This might fake you out, as well. Try to get the bouquet as it leaves the bride's hands and before it is caught—and if your flash recycles fast enough, get a shot of the lucky lady who catches it.

Little Kids

A great photo opportunity comes from spending time with the smallest attendees and attendants: the flower girls and ring bearers. They are usually thrilled with the pageantry of the wedding day, and their involvement often offers a multitude of memorable shots. Remember to get down on the same level as the kids. Make friends with the kids and they will provide many great photo opportunities.

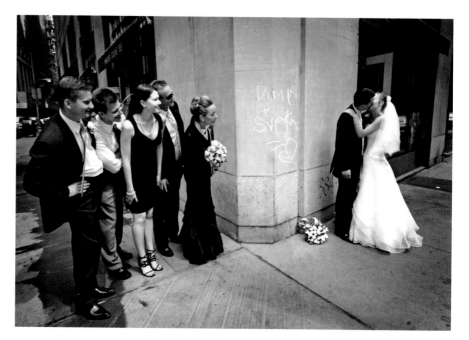

TOP—While this is probably a pose, it's a cute idea pulled off by Emin Kuliyev. A nice touch is the chalk inscribed on the side of the building with the couples' names and a hastily drawn heart.

BOTTOM—All the small children at a wedding seem to find Joe Buissink—or maybe it's vice-versa. In any event, Joe always gets great shots of the kids in the wedding party.

8. Technical Considerations

This image was made with a Canon EF17–40mm f/4L USM at 17mm. The photographer, Dan Doke, says of this image, "I had been photographing a wedding party and posed a group adjacent to the New England Aquarium where the wedding was held. I was drawn to the skyline background. With my camera on a tripod I shot in AV mode and varied the aperture from f/5.6 to f/8. Exposure time was 1.3 seconds at ISO 500. I used a Quantum flash with a Freewire slave. My assistant held the second light and umbrella 45 degrees off to the right and feathered it to create a constant exposure. The flash was set for f/5.6 and I shot a test first. I love it when city lights and the sky are about the same intensity."

This brief chapter deals with a few of the technical aspects of wedding photography that affect posing and how your subjects will be rendered. One of these aspects is lens choice and distance from the camera to the subject. Good perspective, meaning perspective that appears normal to the eye, is no accident and must be controlled by the photographer in order that subjects appear rendered properly.

Focal-Length Factors

Since all but full-frame DSLRs have chip sizes smaller than 24x36mm (the size of a 35mm film frame), there is a magnification factor that changes the effective focal length of the lens. For instance, some Nikon DSLRs have a 1.5X focal-length factor that makes a 50mm f/1.4 lens a 75mm f/1.4 lens—an ideal portrait lens. Other DSLRs may have focal length factors ranging from 1.3X to 1.6X. This is sometimes known as the crop factor. The differences in imaging quality between the full-size image sensors and the

smaller size chips is negligible, although there are slight differences in depth of field.

Focal Length and Its Effect on Perspective

When selecting a lens, the perspective it provides should always be carefully considered.

Wide-Angle Lenses. Wide-angle lenses will distort the subject's appearance, particularly if they are close to the camera or near the edge of the frame. In group portraits, the subjects in the front row will appear larger than those in the back of the group, especially if you get too close. Extreme wide-angle lenses will distort the subjects' appearance, particularly those closest to the frame edges.

"Normal" Lenses. Even "normal" lenses (50mm in 35mm format, 75–90mm in the medium formats) tend to exaggerate subject features at closer working distances. Noses appear elongated, chins jut out, and the backs of heads may appear smaller than normal. This phenomenon is known as foreshortening. At longer working distances (such as when creating three-quarter-length portraits or group portraits), however, normal lenses are a good choice and will provide normal perspective. Raising the camera height, thus placing all subjects at the same relative distance from the lens, can minimize some of this effect. Also, the closer to the center of the frame the people are, the less distorted they will appear.

It is sometimes tricky to blur the background with a normal focal-length lens, since the background is in close proximity to the subjects. However, you can always blur the background elements later in Photoshop.

Short to Medium Telephotos. Short to medium telephotos provide normal perspective without subject distortion, good for close shots of individual subjects and couples. The short telephoto provides a greater working distance

Tight quarters demand wide-angles. Here a 17–50mm f/2.8 lens was used at the 22mm setting. Be sure to keep the subjects away from the frame edges and towards the center of the frame to avoid distortion. Also, don't raise or lower your camera height significantly—keep the height as it is here, about chest height for a three-quarter length portrait. Photograph by Mike Colón.

between camera and subject than the normal lens while increasing the image size to ensure normal perspective.

Long Telephotos. You can even use a much longer lens if you have the working room. When photographing groups, some photographers prefer

BELOW—Short telephotos, in this case an 85mm f/1.4 lens on a Nikon D2X, provide a good working distance from the subject to render normal perspective and are usually very sharp. If used wide open or close to the maximum aperture, they throw the background out of focus for a muted look. Some DSLRs using APS-size image sensors, such as the D2X, have a focal-length factor. This means that the lens does not act like its rated focal length, but is 1.4X or 1.5X greater. In this case, the 85mm lens is acting like a 127mm telephoto. Photograph by Nick Adams.

TOP RIGHT—Stuart Bebb made this image on a Nikon D200 with a 28–70mm f/2.8 lens at 52mm (72mm equivalent). A small handheld video light was used from above to provide some key lighting on the bride. With high-speed zooms like this one, you can alter the cropping to suit the composition and/or perspective and still shoot in very low light.

BOTTOM RIGHT—The 50mm normal lens can make a fine short telephoto portrait lens on a DSLR with a focal-length factor. Fernando Basurto shot this image at f/9.5 to get a clean slate of sharpness, then selectively softened areas of the image in post-production. Note that the perspective, the way the couple is rendered, is excellent.

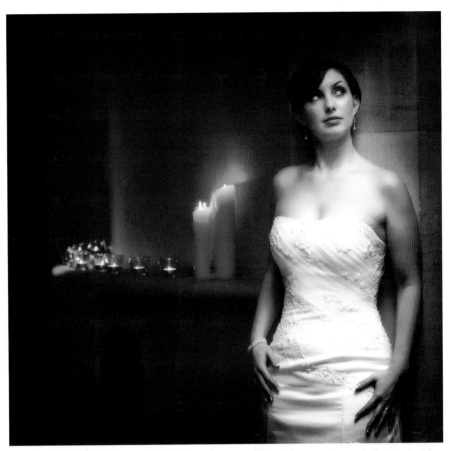

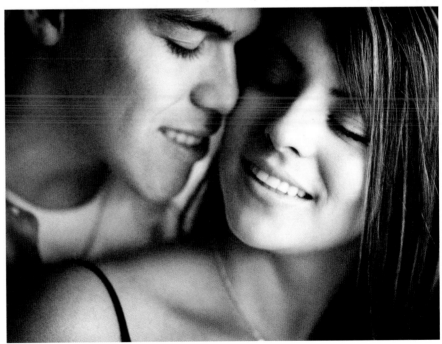

long lenses; for example, a 180mm lens on a 35mm camera. The longer lens keeps people in the back of the group the same relative size as those in the front of the group. A 200mm lens is a beautiful portrait lens for the 35mm format, because it provides very shallow depth of field and throws the background completely out of focus (when used at maximum aperture), providing a backdrop that won't distract viewers from the subject. When used at wider apertures, this focal length provides a very shallow band of focus that can be used to accentuate just the eyes, for instance, or just the frontal planes of the faces.

Very Long Telephotos. Very long lenses (300mm and longer for 35mm) can sometimes distort perspective unless used at awkwardly long camera-to-subject distances. If the working distance is too short, the subject's features appear compressed; the nose may appear pasted onto the subject's face, and the ears may appear parallel to the eyes. These very long lenses are, however, ideal for working unobserved—you can make head-and-shoulders images from a long distance away.

Optimal Lens Choices

A popular lens choice among wedding photographers seems to be the 80–200mm f/2.8 (Nikon) or the 70–200mm f/2.8 (Canon and Nikon). These are very fast, relatively lightweight lenses that offer a wide variety of useful focal lengths for both the ceremony and reception. They are internal focus-

Mike Colón used a 200mm lens on a D2X (creating the equivalent focal length of 300mm), which was ideal for reaching across a great distance to create a close-up portrait of the bride during the ceremony. Because the subject distance is great, there is no perspective distortion.

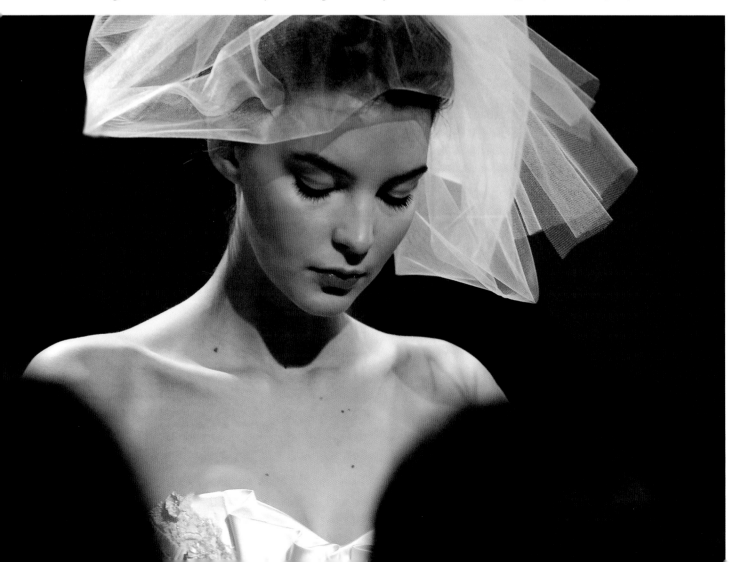

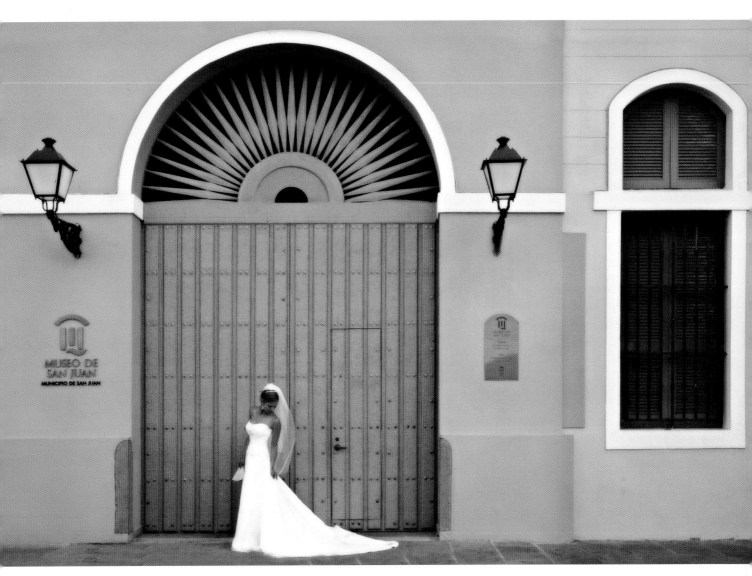

Zoom lenses are optimal for perfect cropping, but good technique also needs to be employed. Here, notice the height of the camera is exactly midway in the photograph, over the bride's head. This is so the photographer, Noel Del Pilar, could get perfectly straight horizontals and verticals in the image. Note how the windows and white horizontal trim are perfectly square. This image was made outside the Museo de San Juan in San Juan, Puerto Rico, where Del Pilar is from.

ing, meaning that autofocus is lightning fast. At the shortest range, 80mm, this lens is perfect for creating full- and three-quarter-length portraits. At the long end, the 200mm setting is ideal for tightly cropped, reception shots or head-and-shoulders portraits.

Other popular lenses include the range of wide angles, both fixed focal length lenses and wide-angle zooms. Focal lengths from 17mm to 35mm are ideal for capturing the atmosphere as well as for photographing larger groups. These lenses are fast enough for use by available light with fast ISOs.

Fast lenses (f/2.8, f/2, f/1.8, f/1.4, f/1.2, etc.) will get lots of work on the wedding day, as they afford many more "available light" opportunities than slower speed lenses. Marcus Bell, an award-winning wedding photographer from Australia, calls his Canon 35mm f/1.4L USM lens his favorite. Shooting at dusk with a high ISO setting, he can work wide open and mix lighting sources for unparalleled results.

Another favorite lens is the high-speed telephoto—the 400mm f/2.8 or 300mm f/4.0 (Nikon) and the 300mm and 400mm f/2.8L (Canon) lenses.

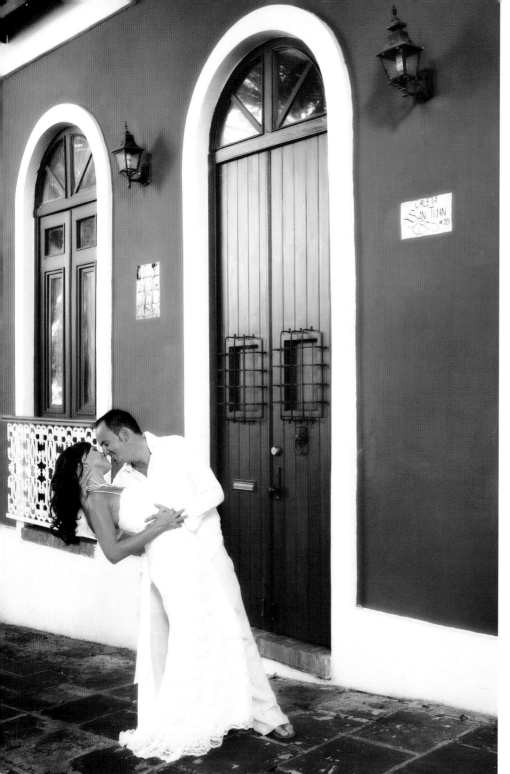

Even wide-angle lenses can produce perfect perspective if you know what you're doing. This image is also by Noel Del Pilar made in San Juan, Puerto Rico, but with an EF 24–70mm f/2.8 Canon lens. Even though Noel did not center the camera from top to bottom (which would have captured near perfect linear perspective), he was able to eliminate the linear distortion in Photoshop by skewing the image (Edit>Transform>Skew), which allows you to correct verticals and horizontals.

These lenses are ideal for working unobserved and can isolate some wonderful moments.

These lenses are ideal for working unobserved and can isolate some wonderful moments, particularly of the ceremony. Even more than the 80–200mm lens, the 300mm or 400mm lenses throw backgrounds beautifully out of focus and, when used wide open, provide a sumptuously thin band of focus, which is ideal for isolating image details. On the negative side, these lenses are heavy and expensive. If using one for the bulk of the day, a monopod is advised.

One of the most popular lenses, whether in Nikon or Canon systems is the 70 (or 80)–200mm f/2.8 lens. It's expensive and heavy but fast and sharp. Here, Bruce Dorn used an EF 70–200mm f/2.8L USM at 130mm. He used a Broncolor strobe for fill, along with a Muslin reflector. The perspective and focus control are elegant. At f/6.3, the only sharp plane is the mask of the face. The hair and bodice are pleasingly soft, and the background is blown out of focus by the 130mm lens setting.

Yet another popular choice is the 85mm (f/1.2 for Canon; f/1.4 or f/1.8 for Nikon), which is a short telephoto with exceptional sharpness. This lens gets used frequently at receptions because of its speed and ability to throw backgrounds out of focus, depending on the subject-to-camera distance. It is one of Marcus Bell's preferred lenses for the majority of his wedding day coverage.

One should not forget about the 50mm f/1.2 or f/1.4 "normal" lens for digital photography. With a 1.5x focal length factor, for example, that lens becomes a 75mm f/1.2 or f/1.4 lens that is ideal for portraits or groups, especially in low light. And the close-focusing distance of this lens makes it an extremely versatile wedding lens.

Zoom Lenses vs. Prime Lenses

Another concern is whether to use prime (fixed focal-length) lenses or zoom lenses. Faster prime lenses will get lots of use, as they afford many more "available light" opportunities than slower speed lenses. Although modern zoom lenses, particularly those designed for digital SLRs, are extremely sharp, many photographers insist that a multipurpose lens cannot possibly be as sharp as a prime lens, which is optimized for use at a single focal length. Mike Colón, a talented photographer from Newport Beach, CA, uses prime lenses (not zooms) in his wedding coverage and shoots at wide-open apertures most of the time to minimize background distractions. He says, "The telephoto lens is my first choice, because it allows me to be far enough away to avoid drawing attention to myself but close enough to clearly capture the moment. Wide-angle lenses, however, are great for shooting from the hip. I can grab unexpected moments all around me without even looking through the lens."

Zoom lenses are also extremely popular however, and offer unbeatable versatility, allowing you to move quickly from wide to tight views. A common choice seems to be the 80–200mm f/2.8 (Nikon) or the 70–200mm f/2.8 (Canon

and Nikon). These are very fast, lightweight lenses that offer a wide variety of useful focal lengths for both the ceremony and reception. They are internal focusing, meaning that the autofocus is lightning fast and the lens does not change length as it is zoomed or focused. At the shortest range, either of these lenses is perfect for creating full- and three-quarter-length portraits. At the long end, the 200mm setting is ideal for tightly cropped, candid shots or head-and-shoulders portraits. These zoom lenses also feature fixed maximum apertures, which do not change as the lens is zoomed. This is a prerequisite for any lens to be used in fast-changing conditions. Lenses with variable maximum apertures provide a cost savings but are not as functional nor as bright in the viewfinder as the faster, fixed-aperture lenses.

BELOW LEFT—Once you get used to focusing the 70- or 80–200mm lenses at various focal-length settings, you will begin to trust the sharpness of these lenses. This beautiful bridal portrait was made by Brett Florens with a Nikon D2X and an AF-S Zoom-NIKKOR 70–200mm f/2.8G IF-ED. The narrow plane of focus at f/2.8 kept the facial mask and bodice sharp and allowed the bouquet to fall quietly out of focus.

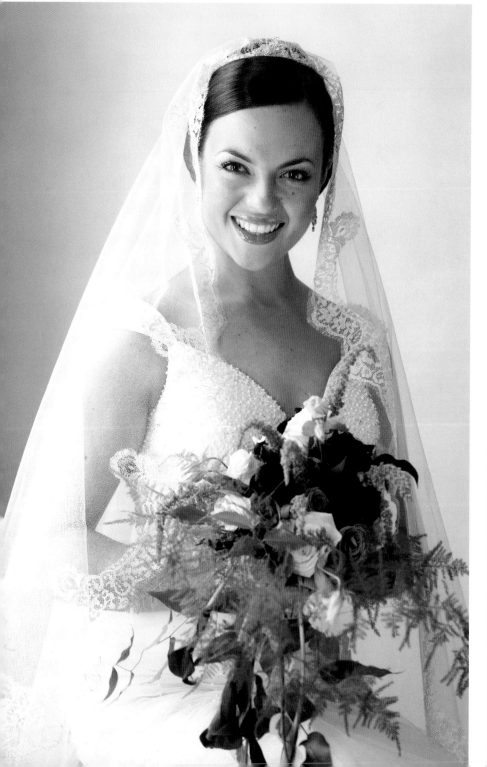

Focusing

The most difficult type of portrait to focus precisely is a head-and-shoulders portrait. It is important that the eyes and frontal planes of the face be tack-sharp. (*Note:* It is usually desirable for the ears to be sharp as well, but not always.) When working at wide lens apertures, where depth of field is reduced, you must focus carefully to achieve this. This is where a good knowledge of your lenses comes in handy. Some lenses will have the majority of their depth of field behind the focus point; others will have the majority of their depth of field in front of the point of focus. In most cases, the depth of field is split 50/50; half in front of and half behind the point of focus. Check the depth of field with the lens stopped down to your taking aperture (using your cam-

BELOW LEFT—When using wide-angle lenses, especially extreme wide-angles, which have inherently more depth of field than longer focal lengths, an intermediate aperture of f/5 will provide all the depth of field you need. Here, the forest and the foreground are razor sharp in this image by Brett Florens, which was made at f/5 with a 12–24mm f/4 lens.

Joe Buissink made this charming image of a flower girl doing some last-minute housekeeping duties, with a 70–200mm lens at f/2.8. His focus is in sync with the storytelling aspects of the image. The face, hands, and basket of the little girl are all in focus, but nothing else is, so that the impact of the image derives from its significant elements. Depth of focus entails knowing exactly where to place the point of sharp focus so that the details convey the intended message.

era's depth of field preview control) or check a test frame on the LCD by zooming in on the details to inspect sharpness.

Focusing a three-quarter- or full-length portrait is a little easier because you are farther from the subject, where depth of field is greater. For best results, split your focus halfway between the closest and farthest points that you want sharp on the subject. It is a good idea to work at wide open or near wide-open apertures to keep your background out of focus.

Shooting Apertures

Often, you don't have much of a choice in the aperture you select—especially when using electronic flash or when shooting outdoors. When you do have a choice, though, experts say to choose an aperture that is 1.5 to 2 stops smaller than the lens's maximum aperture. For instance, the optimum lens aperture of an f/2 lens would be around f/4.

The optimum aperture, however, may not always be small enough to provide adequate depth of field for a head-and-shoulders portrait, so it is often necessary to stop down. These apertures are small enough to hold the face in focus, but not small enough to pull the background into focus. They usually also provide a fast enough shutter speed to stop subtle camera or subject movement. Note that the use of optimum lens apertures is dependent on the overall light level and the ISO you are using.

A technique that has been perfected by sports photographers and other photojournalists is to use the fastest possible shutter speed and widest possible lens aperture. The technique does two things: it quells all possible subject and camera movement and, depending on the camera to subject distance, it allows the background to fall completely out of focus at certain distances. When telephoto lenses are used wide open and close to a subject, the effects are even more exaggerated, creating razor thin planes of focus on the face.

The effects are even more exaggerated, creating razor thin planes of focus on the face.

Some might consider attempting a shot like this handheld to be foolhardy. Kevin Jairaj made this image using a shutter speed of $\frac{1}{30}$ at f/2.8 and an ISO of 1600. You get fooled thinking that the little overhead light is the only light in the room. But if it were, the shadows it cast would be downward from overhead. Instead, Kevin used a sharp but minimally powered handheld video light to light the area around the subjects' faces. The image was then vignetted in post-processing.

with clear lines of defocus visible. It is a stylized effect that continues to enjoy great popularity.

Shutter Speeds

You must choose a shutter speed that stills both camera and subject movement. If using a tripod, a shutter speed of $\frac{1}{15}$ to $\frac{1}{60}$ second should be adequate to stop average subject movement. Outdoors, you should normally choose a shutter speed faster than $\frac{1}{60}$ second, because even a slight breeze will cause the subject's hair to flutter, producing motion during the moment of exposure. If you are using electronic flash, you are locked into the flash-sync speed your camera calls for unless you are dragging the shutter (working at a slower-than-flash-sync shutter speed to bring up the level of the ambient light).

When handholding the camera, you should select a shutter speed that is the reciprocal of the focal length of the lens you are using (or faster). For example, if using a 100mm lens, use $\frac{1}{100}$ second (or the next highest equivalent shutter speed, like $\frac{1}{125}$) under average conditions. Some photographers are able to handhold their cameras for impossibly long exposures, like $\frac{1}{4}$ or $\frac{1}{2}$ second. To do this, you must practice good breathing and shooting techniques. With the handheld camera laid flat in the palm of your hand and your elbows in against your body, take a deep breath and hold it. Do not exhale until you've squeezed the shutter. Spread your feet like a tripod and if you are near a doorway, lean against it for additional support.

If you are shooting handheld and working very close to the subjects, as you might be when making a portrait of a couple, you will need to use a faster shutter speed because of the increased image magnification. When working farther away from the subject, you can revert to the shutter

speed that is the reciprocal of your lens's focal length. When shooting subjects in motion, use a faster shutter speed and a wider lens aperture. In this kind of shot, it's more important to freeze subject movement than it is to have great depth of field. Ultimately, if you have any question as to which speed to use, use the next fastest speed to ensure sharpness.

Image Stabilization Lenses

A great technical improvement is the development of image stabilization lenses, which correct for camera movement and allow you to shoot handheld with long lenses and slower shutter speeds. Canon and Nikon, two companies that currently offer this feature in some of their lenses, offer a wide variety of zooms and long focal length lenses with image stabilization. If using a zoom, for instance, with a maximum aperture of $f/4$, you can shoot handheld wide open in subdued light at $\frac{1}{10}$ or $\frac{1}{15}$ second and get sharp results. This means that you can use the natural light longer into the day while still shooting at low ISO settings for fine image structure. It is important to note, however, that subject movement will not be quelled with these lenses, only camera movement.

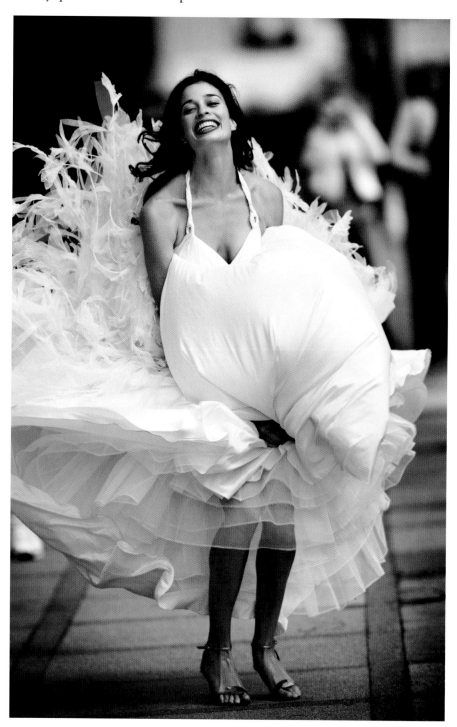

This is one of my all-time favorite wedding images. The photographer, Mike Colón, used an AF-S VR Nikkor 200mm f/2G IF-ED lens, which is astronomically expensive (with diamonds you pay for size [karats]; with lenses you pay for speed [f/2.0]). Naturally, Mike shoots wide open to exploit the very shallow depth of field and impeccable sharpness of this lens. With VR (vibration reduction) technology on board, he never has to worry about shutter speed.

Conclusion

As noted at the beginning of this book, there are many reasons for the changes in wedding photography—the influence of wedding photojournalism, brides' more contemporary and casual attitudes toward their wedding pictures, and the changing styles of the photographers themselves, just to name a few. Still, even in the most free-form wedding treatments, you can see the rudiments of formal posing. Some of the posing fine points of the traditionalists have, naturally, gone by the wayside, but many of the fundamentals are still being used—and used frequently.

Recently, there has been a return to "directed" posing, probably a response to the immense pressure on the photographers to keep producing unforgettable images. While most still do not "formulize" their shooting as was done when photographers worked from a shot list, a number of images will be formal in nature and done pretty much by the book. These include family portraits, wedding-party images, bridal party portraits, and so on.

Another great influence on contemporary wedding photography is the complete and total domination of digital imaging. While no one downplays the speed and convenience of digital photography, a noticeable byproduct is the influx of people, sometimes unqualified, who have "become" wedding photographers. As many disappointed brides are finding out, the true professional photographer, an experienced artist who brings an arsenal of skills and techniques to the event, is far better qualified to provide exceptional results and well prepared to overcome the myriad of problems that tend to crop up on a wedding day.

The top professionals are also well versed in making people look good in pictures. This is why the wedding has become one of the highest-paid sectors of professional photography. One important skill that the professional wedding photographer employs every time he or she offers a suggestion to the subject is an understanding of how the human form should be rendered—in short, the art of posing.

It is my hope that you enjoyed this book and will put many of the techniques to work in your wedding photography. As usual, thanks to the many great photographers who contributed their images and expertise to this book. It would not have been possible without them.

Even in the most free-form wedding treatments, you can see the rudiments of formal posing.

The Photographers

Nick and Signe Adams. Nick and Signe Adams started Nick Adams Photography in St. George, UT, in 2002. They have been winning awards since they first became WPPI members. They maintain a boutique-type studio business in an historic section of St. George. View their website at www.nickadams.com.

Fernando Basurto *(APM, AOPA).* Fernando is a wedding photographer who does business in historical uptown Whittier area of Southern California. Specializing in wedding photojournalism Fernando has created some of the most powerful and passionate wedding images of today. His work can be seen at www.elegantphotographer.com/.

Stuart Bebb. Stuart Bebb is a Craftsman of the Guild of Photographers UK and has been awarded Wedding Photographer of the Year in both 2000 and 2002. In 2001 Stuart won *Cosmopolitan Bride* Wedding Photographer of the Year. He was also a finalist in the Fuji wedding photographer of the Year. Stuart has been capturing stunning wedding images for over twenty years and works with his wife Jan, who creates and designs all the albums.

Marcus Bell. Marcus Bell's creative vision, fluid natural style and sensitivity have made him one of Australia's most revered photographers. It's this talent combined with his natural ability to make people feel at ease in front of the lens that attracts so many of his clients. Marcus' work has been published in numerous magazines in Australia and overseas including *Black White, Capture, Portfolio Bride,* and countless other bridal magazines.

Joe Buissink. Joe Buissink is an internationally recognized wedding photographer from Beverly Hills, CA. Almost every potential bride who picks up a bridal magazine will have seen Joe Buissink's photography. He has photographed numerous celebrity weddings, including Christina Aguilera's 2005 wedding, and is a multiple Grand Award winner in WPPI print competition.

Mark Cafeiro. Mark graduated from the University of Northern Colorado with a degree in Business Administration with special emphasis in Marketing. He is the owner of several photography businesses, including Pro Photo Alliance, an online proofing solution for labs and professional photographers, and his own private wedding, event, and portrait business.

Mike Colón. Mike Colón is a celebrated wedding photojournalist from the San Diego area. Colón's natural and fun approach frees his subjects to be themselves, revealing their true personality and emotion. His images combine inner beauty, joy, life, and love frozen in time forever. He has spoken before national audiences on the art of wedding photography.

Cherie Steinberg Coté. Cherie Steinberg Coté began her photography career as a photojournalist at the *Toronto Sun,* where she had the distinction of being the first female freelance photographer. She currently lives in Los Angeles and has recently been published in the *L.A. Times, Los Angeles Magazine,* and *Town & Country.*

Jerry D. Jerry D owns and operates Enchanted Memories, a successful portrait and wedding studio in Upland, CA. Jerry has had several careers in his lifetime, from licensed cosmetologist to black belt martial arts instructor. Jerry is a highly decorated photographer by WPPI and has achieved many national awards since joining the organization.

Noel Del Pilar. Noel is an award-winning wedding photographer from San Juan, Puerto Rico. After fifteen years of photographing weddings, he has established a reputation as a wedding photographer on the cutting edge; his embrace of wedding photojournalism has helped transform the look of wedding photography in Puerto Rico today. Noel specializes in destination weddings and is a preferred vendor of some of the best hotels in Puerto Rico.

Jesh de Rox. Jesh de Rox is a Canadian photographer from Edmonton, Alberta who burst onto the wedding photography scene at the WPPI 2006 convention, where 38 of his entries scored 80 or above. He now teaches extensively all over the country and has a growing wedding business. He is the author and designer of Fine Art Textures, for sale to other photographers for enhancing their artwork, available at www.jeshderox.com.

Dan Doke. Daniel has a drive for perfection, abundant creativity, and special eye for light and form. He is a modern photographer with traditional skills, who draws on his experience in commercial, fashion, and portrait photography to create memorable wedding images.

Mauricio Donelli. Mauricio Donelli is a world-famous wedding photographer from Miami, FL. His work is a combination of styles, consisting of traditional photojournalism with a twist of fashion and art. His weddings are photographed in what he calls, "real time." His photographs have been published in *Vogue, Town & Country,* and many national and international magazines. He has photographed weddings around the world.

Bruce Dorn. Bruce Hamilton Dorn of iDC Photography has twenty years of Hollywood filmmaking experience, which shaped his cinematic style of wedding photography. As a member of the Director's Guild of America, Bruce's commercial clients included McDonalds, Sony, Budweiser, and Ford. Bruce, with his artistic partner and wife Maura Dutra, now offers this award-winning expertise to a select group of artistically-inclined wedding clients.

Rick Ferro. Rick has served as senior wedding photographer at Walt Disney World and received many awards from WPPI. He has photographed over 10,000 weddings and is the author of *Wedding Photography: Creative Techniques for Lighting and Posing,* and coauthor of *Wedding Photography with Adobe Photoshop,* both from Amherst Media.

Brett Florens. Having started his career as a photojournalist, Brett Florens has become a renowned international wedding photographer, traveling from his home in South Africa to Europe, Australia, and the U.S. for the discerning bridal couple requiring the ultimate in professionalism and creativity. His exceptional albums are fast making him the "must have" photographer around the globe.

Jerry Ghionis. Jerry Ghionis of XSiGHT Photography and Video is one of Australia's leading photographers. In 1999, he was honored with the AIPP (Australian Institute of Professional Photography) award for best new talent in Victoria. In 2002, he won the AIPP's Victorian Wedding Album of the Year; a year later, he won the Grand Award in WPPI's album competition.

Greg Gibson. Greg is a two-time Pulitzer Prize winner whose assignments have included three Presidential campaigns, daily coverage of the White House, the Gulf War, Super Bowls, and much more. Despite numerous offers to return to journalism, Greg finds shooting weddings the perfect genre to continually test his skills.

Jeff and Kathleen Hawkins. Jeff and Kathleen operate a high-end wedding and portrait photography studio in Orlando, FL, and are the authors of *Professional Marketing &*

Selling Techniques for Wedding Photographers (Amherst Media). Jeff has been a professional photographer for over twenty years. Kathleen holds an MBA and is a past president of the Wedding Professionals of Central Florida (WPCF). They can be reached at www.jeffhawkins.com.

Gene Higa. Gene Higa travels the world doing what he loves: photographing weddings. He is one of the most sought-after wedding photographers in the world. Originally from Los Angeles, Gene makes his home in San Francisco, but calls the world his office. He has been commissioned to photograph weedings in Spain, the Philippines, Peru, India, Italy, Greece, Mexico, Hawaii, Jamaica, Thailand and on and on. For more, visit www.genehiga.com.

Kevin Jairaj. Kevin is a fashion photographer turned wedding and portrait photographer whose creative eye has earned him a stellar reputation in the Dallas/Fort Worth, TX area. His web site is: www.kjimages.com.

Jeff Kolodny. Jeff Kolodny began his career as a professional photographer in 1985 after receiving a BA in Film Production from Adelphi University in New York. Jeff recently relocated his business from Los Angeles to South Florida, where his ultimate goal is to produce digital wedding photography that is cutting edge and sets him apart from others in his field.

Claudia Kronenberg. Claudia Kronenberg is the owner of CKP, Inc., and a master at multitasking. She shoots weddings and portraits, handles marketing and business for the studio, and is breaking out into the national speaking world. Her passion for her profession is unparalleled. She can be contacted via www.claudiak.com.

Emin Kuliyev. Emin is originally from Russia, a large town in Azerbaijan. He has been photographing weddings in New York for more than six years and he has trained under many respected photographers from around the world. He started his own wedding studio in the Bronx in 2000. Today he is a well respected and award-winning wedding photographer.

Laszlo. Laszlo Mezei immigrated to Canada after the 1956 Hungarian uprising. He studied photography and art history in New York City. He became a master portrait photographer, versatile in all formats and he became especially skillful as a lighting expert. He built a high-end business producing portraits in the tradition of the Dutch Masters. His work can be seen at: www.laszlomontreal.com.

Scott Robert Lim. Scott is an Los Angeles photographer and educator with a compelling style that blends both photojournalism and portraiture with a modern flair. He is a preferred photographer at many world-renowned establishments, such as the Hotel Bel-Air.

Charles and Jennifer Maring. Charles and Jennifer Maring own Maring Photography Inc. in Wallingford, CT. His parents, also photographers, operate Rlab (resolutionlab.com), a digital lab that does all of the work for Maring Photography and other discriminating photographers. Charles Maring was the winner of WPPI's Album of the Year Award in 2001.

Annika Metsla. Photographer Annika Metsla lives in Estonia, a small country in Eastern Europe between Latvia and Russia, bordering the Baltic Sea and Gulf of Finland. An active member of WPPI, Annika operates a thriving photography and wedding planning business, and has recently won a number of awards in WPPI competitions. Visit her at www.annikametsla.com.

Tom Muñoz. Tom Muñoz is a fourth-generation photographer whose studio is in Fort Lauderdale, FL. Tom upholds the classic family traditions of posing, lighting, and composition, yet is 100-percent digital. He believes that the traditional techniques blend perfectly with exceptional quality of digital imaging.

Gordon Nash. Gordon Nash owns A Paradise Dream Wedding, one of Hawaii's largest and most successful wedding photography and coordination businesses. He also developed a second, lower-end wedding company called Aekai Beach, staffed by younger photographers whom he mentors. To learn more, visit www.gordonnash.com and www.mauiwedding.net.

Mark Nixon. Mark, who runs The Portrait Studio in Clontarf, Ireland, recently won Ireland's most prestigious photographic award with a panel of four wedding images. He is currently expanding his business to be international in nature and he is on the worldwide lecture circuit.

Michael O'Neill. As an advertising and editorial photographer who specializes in people, personalities, and product illustration, Michael O'Neill has worked clients including Nikon USA, The New York Jets, Calvin Klein, and Avis. Finding his editorial style of portraiture being the most sought after of his creations, Michael narrowed his specialty to producing portraits—not only for large corporate concerns, but for a discriminating retail market as well.

Dennis Orchard. Dennis Orchard is an award-winning photographer from Great Britain. He is a member of the British Guild of portrait and wedding photographers, and has been a speaker and an award-winner at numerous WPPI conventions. His unique wedding photography has earned him many awards, including WPPI's Accolade of Lifetime Photographic Excellence.

Parker Pfister. Parker Pfister, who shoots weddings locally in Hillsboro, OH, as well as in neighboring states, is quickly developing a national celebrity. He is passionate about what he does and can't imagine doing anything else (although he also has a beautiful portfolio of fine-art nature images). Visit him at www.pfisterphoto-art.com.

Norman Phillips *(AOPA)*. Norman is an acclaimed professional photographer and a frequent contributor to photographic publications. He is also the author of numerous books, including *Wedding and Portrait Photographers' Legal Handbook,* from Amherst Media.

Joe Photo. Joe Photo's wedding images have been featured in numerous publications such as *Grace Ormonde's Wedding Style, Elegant Bride, Wedding Dresses,* and *Modern Bride.* His weddings have also been seen on NBC's *Life Moments* and Lifetime's *Weddings of a Lifetime* and *My Best Friend's Wedding.*

John Poppleton. Utah photographer John Poppleton delights in urban decay—lathe and plaster, peeling paint, weathered wood, and rusted metal. He "enjoys the color, line, and texture of old architecture." However, he also loves to create people photography—especially uniquely feminine portraiture. When the architecture of urban decay combines with elegant brides, the startling result is Poppleton's unique style.

John Ratchford. John is from Eastern Canada and has introduced the senior-portrait market to Canada. His images have captured many national and international awards. John has a thriving wedding business and is the author of the upcoming book, *Essence of Life,* featuring a collection of prenatal and newborn images.

JB and DeEtte Sallee. Sallee Photography has only been in business since 2003, but it has already earned many accomplishments. In 2004, JB received the first Hy Sheanin Memorial Scholarship through WPPI. In 2005, JB and DeEtte were also named Dallas Photographer of The Year.

Martin Schembri *(M.Photog. AIPP)*. Martin Schembri has been winning national awards in his native Australia for 20 years. He has achieved a Double Master of Photography with the AIPP. He is an internationally recognized portrait, wedding, and commercial photographer and has conducted seminars on his unique style of creative photography all over the world.

Ryan Schembri. Ryan Schembri has grown up in the world of wedding photography, having worked with his dad, Martin Schembri, since the age of twelve. In 2004, at the age of twenty, Ryan became the youngest Master of Photography with the Australian Institute of Professional Photographers. He has gone on to earn other distinctions and has also spoken at seminars around the world. Visit www.martinschembri.com.au to learn more.

Kenneth Sklute. Kenneth began his career in Long Island, and now operates a thriving studio in Arizona. He has been named Long Island Wedding Photographer of The Year (fourteen times!), PPA Photographer of the Year, and APPA Wedding Photographer of the Year. He has also earned numerous Fuji Masterpiece Awards and Kodak Gallery Awards.

Jose Villa. Jose Villa's fine-art wedding photography has been featured in many magazines around the world, including *Martha Stewart Weddings, Grace Ormonde Wedding Style, Go, Wedding Style New England, Pacific Rim Weddings, Brides, The Knot, Inside Weddings, Instyle Weddings, PDN's* wedding issue and *American Photo's* wedding issue.

Marc Weisberg. Marc Weisberg specializes in wedding and event photography. A graduate of UC Irvine with a degree in fine art and photography, he also attended the School of Visual Arts in New York City before relocating to Southern California in 1991. His images have been featured in *Wines and Spirits, Riviera, Orange Coast Magazine,* and *Where Los Angeles.*

Kristi and Paul Wolverton. Kristi and Paul Wolverton are two master photographers, each with a unique perspective. This rare combination of two international award-winning photographers ensures that each event is captured and documented in a style that is both current and timeless.

Jeffrey and Julia Woods. Jeffrey and Julia Woods are award-winning wedding and portrait photographers who work as a team. They were awarded WPPI's Best Wedding Album of the Year for 2002 and 2003, two Fuji Masterpiece awards, and a Kodak Gallery Award. See more of their images at www.jwweddinglife.com.

David Worthington. David Worthington is a professional photographer who specializes in classical wedding photography. Two of David's most recent awards include being named 2003's Classical Wedding Photographer of the Year (UK, Northwest Region) and Licentiate Wedding Photographer of the Year (UK, Northwest Region).

Yervant Zanazanian *(M. Photog. AIPP, F.AIPP).* Yervant was born in Ethiopia (East Africa), where he worked after school at his father's photography business (his father was photographer to the Emperor Hailé Silassé of Ethiopia). Yervant owns one of the most prestigious photography studios of Australia and services clients both nationally and internationally.

Index

WEDDING PHOTOGRAPHER'S HANDBOOK

Bill Hurter

Learn to produce images with technical proficiency and superb, unbridled artistry. Includes images and insights from top industry pros. $34.95 list, 8.5x11, 128p, 180 color photos, 10 screen shots, index, order no. 1827.

RANGEFINDER'S PROFESSIONAL PHOTOGRAPHY

edited by Bill Hurter

Editor Bill Hurter shares over one hundred "recipes" from *Rangefinder's* popular cookbook series, showing you how to shoot, pose, light, and edit fabulous images. $34.95 list, 8.5x11, 128p, 150 color photos, index, order no. 1828.

SIMPLE LIGHTING TECHNIQUES

FOR PORTRAIT PHOTOGRAPHERS

Bill Hurter

Make complicated lighting setups a thing of the past. In this book, you'll learn how to streamline your lighting for more efficient shoots and more natural-looking portraits. $34.95 list, 8.5x11, 128p, 175 color images, index, order no. 1864.

MASTER LIGHTING GUIDE

FOR WEDDING PHOTOGRAPHERS

Bill Hurter

Capture perfect lighting quickly and easily at the ceremony and reception—indoors and out. Includes tips from the pros for lighting individuals, couples, and groups. $34.95 list, 8.5x11, 128p, 200 color photos, index, order no. 1852.

PHOTOGRAPHER'S GUIDE TO WEDDING ALBUM DESIGN AND SALES, 2nd Ed.

Bob Coates

Learn how industry leaders design, assemble, and market their albums with the insights and advice in this popular book. $34.95 list, 8.5x11, 128p, 175 full-color images, index, order no. 1865.

LIGHTING FOR PHOTOGRAPHY TECHNIQUES FOR STUDIO AND LOCATION SHOOTS

Dr. Glenn Rand

Gain the technical knowledge of natural and artificial light you need to take control of every scene you encounter—and produce incredible photographs. $34.95 list, 8.5x11, 128p, 150 color images/diagrams, index, order no. 1866.

SCULPTING WITH LIGHT

Allison Earnest

Learn how to design the lighting effect that will best flatter your subject. Studio and location lighting setups are covered in detail with an assortment of helpful variations provided for each shot. $34.95 list, 8.5x11, 128p, 175 color images, diagrams, index, order no. 1867.

MASTER'S GUIDE TO WEDDING PHOTOGRAPHY

CAPTURING UNFORGETTABLE MOMENTS AND LASTING IMPRESSIONS

Marcus Bell

Learn to capture the unique energy and mood of each wedding and build a lifelong client relationship. $34.95 list, 8.5x11, 128p, 200 color photos, index, order no. 1832.

MASTER LIGHTING GUIDE

FOR COMMERCIAL PHOTOGRAPHERS

Robert Morrissey

Use the tools and techniques pros rely on to land corporate clients. Includes diagrams, images, and techniques for a failsafe approach for shots that sell. $34.95 list, 8.5x11, 128p, 110 color photos, 125 diagrams, index, order no. 1833.

STEP-BY-STEP WEDDING PHOTOGRAPHY

Damon Tucci

Deliver the top-quality images that your clients demand with the tips in this essential book. Tucci shows you how to become more creative, more efficient, and more successful. $34.95 list, 8.5x11, 128p, 175 color images, index, order no. 1868.

Other Books by Bill Hurter

PORTRAIT PHOTOGRAPHER'S HANDBOOK, 3rd Ed.

A step-by-step guide that easily leads the reader through all phases of portrait photography. This book will be an asset to experienced photographers and beginners alike. $34.95 list, 8.5x11, 128p, 175 color photos, order no. 1844.

THE BEST OF CHILDREN'S PORTRAIT PHOTOGRAPHY

Rangefinder editor Bill Hurter draws upon the experience and work of top professional photographers, uncovering the creative and technical skills they use to create their magical portraits of these young subjects. $29.95 list, 8.5x11, 128p, 150 color photos, order no. 1752.

GROUP PORTRAIT PHOTOGRAPHY HANDBOOK 2nd Ed.

Featuring over 100 images by top photographers, this book offers practical techniques for composing, lighting, and posing group portraits—whether in the studio or on location. $34.95 list, 8.5x11, 128p, 120 color photos, order no. 1740.

THE BEST OF WEDDING PHOTOGRAPHY, 3rd Ed.

Learn how the top wedding photographers in the industry transform special moments into lasting romantic treasures with the posing, lighting, album design, and customer service pointers found in this book. $34.95 list, 8.5x11, 128p, 200 color photos, order no. 1837.

THE BEST OF WEDDING PHOTOJOURNALISM

Learn how top professionals capture these fleeting moments of laughter, tears, and romance. Features images from over twenty renowned wedding photographers. $34.95 list, 8.5x11, 128p, 150 color photos, index, order no. 1774.

THE PORTRAIT PHOTOGRAPHER'S GUIDE TO POSING

Posing can make or break an image. Now you can get the posing tips and techniques that have propelled the finest portrait photographers in the industry to the top. $34.95 list, 8.5x11, 128p, 200 color photos, index, order no. 1779.

WEDDING PHOTOGRAPHER'S HANDBOOK

Learn to produce images with technical proficiency and superb, unbridled artistry. Includes images and insights from top industry pros. $34.95 list, 8.5x11, 128p, 180 color photos, 10 screen shots, index, order no. 1827.

RANGEFINDER'S PROFESSIONAL PHOTOGRAPHY

Editor Bill Hurter shares over one hundred "recipes" from *Rangefinder's* popular cookbook series, showing you how to shoot, pose, light, and edit fabulous images. $34.95 list, 8.5x11, 128p, 150 color photos, index, order no. 1828.

MASTER LIGHTING GUIDE
FOR WEDDING PHOTOGRAPHERS

Capture perfect lighting quickly and easily at the ceremony and reception—indoors and out. Includes tips from the pros for lighting individuals, couples, and groups. $34.95 list, 8.5x11, 128p, 200 color photos, index, order no. 1852.

EXISTING LIGHT
TECHNIQUES FOR WEDDING AND PORTRAIT PHOTOGRAPHY

Learn to work with window light, make the most of outdoor light, and use fluorescent and incan-descent light to best effect. $34.95 list, 8.5x11, 128p, 150 color photos, index, order no. 1858.

100 TECHNIQUES FOR PROFESSIONAL WEDDING PHOTOGRAPHERS

Top photographers provide tips for becoming a better shooter—from optimizing your gear, to capturing perfect moments, to streamlining your workflow. $34.95 list, 8.5x11, 128p, 180 color images and diagrams, index, order no. 1875.

SIMPLE LIGHTING TECHNIQUES
FOR PORTRAIT PHOTOGRAPHERS

Make complicated lighting setups a thing of the past. In this book, you'll learn how to streamline your lighting for more efficient shoots and more natural-looking portraits. $34.95 list, 8.5x11, 128p, 175 color images, index, order no. 1864.

ROLANDO GOMEZ'S
POSING TECHNIQUES FOR GLAMOUR PHOTOGRAPHY

Learn everything you need to pose a subject—from head to toe. Gomez covers each area of the body in detail, showing you how to address common problems and create a flattering look. $34.95 list, 8.5x11, 128p, 110 color images, index, order no. 1869.

PROFESSIONAL WEDDING PHOTOGRAPHY

Lou Jacobs Jr.

Jacobs explores techniques and images from over a dozen top professional wedding photographers in this revealing book, taking you behind the scenes and into the minds of the masters. $34.95 list, 8.5x11, 128p, 175 color images, index, order no. 2004.

THE ART OF CHILDREN'S PORTRAIT PHOTOGRAPHY

Tamara Lackey

Learn how to create images that are focused on emotion, relationships, and storytelling. Lackey shows you how to engage children, conduct fun and efficient sessions, and deliver images that parents will cherish. $34.95 list, 8.5x11, 128p, 240 color images, index, order no. 1870.

EVENT PHOTOGRAPHY HANDBOOK

W. Folsom and J. Goodridge

Learn how to win clients and create outstanding images of award ceremonies, grand openings, political and corporate functions, and other special occasions. $34.95 list, 8.5x11, 128p, 150 color images, index, order no. 1871.

50 LIGHTING SETUPS FOR PORTRAIT PHOTOGRAPHERS

Steven H. Begleiter

Filled with unique portraits and lighting diagrams, plus the "recipe" for creating each one, this book is an indispensible resource you'll rely on for a wide range of portrait situations and subjects. $34.95 list, 8.5x11, 128p, 150 color images and diagrams, index, order no. 1872.

DIGITAL PHOTOGRAPHY BOOT CAMP, 2nd Ed.

Kevin Kubota

This popular book based on Kevin Kubota's sell-out workshop series is now fully updated with techniques for Adobe Photoshop and Lightroom. It's a down-and-dirty, step-by-step course for professionals! $34.95 list, 8.5x11, 128p, 220 color images, index, order no. 1873.

100 TECHNIQUES FOR PROFESSIONAL WEDDING PHOTOGRAPHERS

Bill Hurter

Top photographers provide tips for becoming a better shooter—from optimizing your gear, to capturing perfect moments, to streamlining your workflow. $34.95 list, 8.5x11, 128p, 180 color images and diagrams, index, order no. 1875.

BUTTERFLY PHOTOGRAPHER'S HANDBOOK

William B. Folsom

Learn how to locate butterflies, approach without disturbing them, and capture spectacular, detailed images. $34.95 list, 8.5x11, 128p, 175 color images, index, order no. 1877.

500 POSES FOR PHOTOGRAPHING WOMEN

Michelle Perkins

A vast assortment of inspiring images, from head-and-shoulders to full-length portraits, and classic to contemporary styles—perfect for when you need a little shot of inspiration to create a new pose. $34.95 list, 8.5x11, 128p, 500 color images, order no. 1879.

POWER MARKETING, SELLING, AND PRICING
A BUSINESS GUIDE FOR WEDDING AND PORTRAIT PHOTOGRAPHERS, 2ND ED.

Mitche Graf

Master the skills you need to take control of your business, boost your bottom line, and build the life you want. $34.95 list, 8.5x11, 144p, 90 color images, index, order no. 1876.

MINIMALIST LIGHTING
PROFESSIONAL TECHNIQUES FOR STUDIO PHOTOGRAPHY

Kirk Tuck

Learn how technological advances have made it easy and inexpensive to set up your own studio for portrait photography, commercial photography, and more. $34.95 list, 8.5x11, 128p, 190 color images and diagrams, index, order no. 1880.

MASTER POSING GUIDE FOR WEDDING PHOTOGRAPHERS

Bill Hurter

Learn a balanced approach to wedding posing and create images that make your clients look their very best while still reflecting the spontaneity and joy of the event. $34.95 list, 8.5x11, 128p, 180 color images and diagrams, index, order no. 1881.

ELLIE VAYO'S GUIDE TO
BOUDOIR PHOTOGRAPHY

Learn how to create flattering, sensual images that women will love as gifts for their significant others or keepsakes for themselves. Covers everything you need to know—from getting clients in the door, to running a successful session, to making a big sale. $34.95 list, 8.5x11, 128p, 180 color images, index, order no. 1882.

MASTER GUIDE FOR
PHOTOGRAPHING HIGH SCHOOL SENIORS

Dave, Jean, and J. D. Wacker

Learn how to stay at the top of the ever-changing senior portrait market with these techniques for success. $34.95 list, 8.5x11, 128p, 270 color images, index, order no. 1883.

PHOTOGRAPHING JEWISH WEDDINGS

Stan Turkel

Learn the key elements of the Jewish wedding ceremony, terms you may encounter, and how to plan your schedule for flawless coverage of the event. $39.95 list, 8.5x11, 128p, 170 color images, index, order no. 1884.

AVAILABLE LIGHT

PHOTOGRAPHIC TECHNIQUES FOR USING EXISTING LIGHT SOURCES

Don Marr

Don Marr shows you how to find great light, modify not-so-great light, and harness the beauty of some unusual light sources in this step-by-step book. $34.95 list, 8.5x11, 128p, 135 color images, index, order no. 1885.

JEFF SMITH'S GUIDE TO
HEAD AND SHOULDERS PORTRAIT PHOTOGRAPHY

Jeff Smith shows you how to make head and shoulders portraits a more creative and lucrative part of your business—whether in the studio or on location. $34.95 list, 8.5x11, 128p, 200 color images, index, order no. 1886.

THE PHOTOGRAPHER'S GUIDE TO
MAKING MONEY

150 IDEAS FOR CUTTING COSTS AND BOOSTING PROFITS

Karen Dórame

Learn how to reduce overhead, improve marketing, and increase your studio's overall profitability. $34.95 list, 8.5x11, 128p, 200 color images, index, order no. 1887.

ON-CAMERA FLASH

TECHNIQUES FOR DIGITAL WEDDING AND PORTRAIT PHOTOGRAPHY

Neil van Niekerk

Discover how you can use on-camera flash to create soft, flawless lighting that flatters your subjects—and doesn't slow you down on location shoots. $34.95 list, 8.5x11, 128p, 190 color images, index, order no. 1888.

MASTER LIGHTING GUIDE

FOR PORTRAIT PHOTOGRAPHERS

Christopher Grey

Efficiently light executive and model portraits, high and low key images, and more. Master traditional lighting styles and use creative modifications that will maximize your results. $29.95 list, 8.5x11, 128p, 300 color photos, index, order no. 1778.

LIGHTING TECHNIQUES

FOR PHOTOGRAPHING MODEL PORTFOLIOS

Billy Pegram

Learn how to light images that will get you—and your model—noticed. Pegram provides start-to-finish analysis of real-life sessions, showing you how to make the right decisions each step of the way. $34.95 list, 8.5x11, 128p, 150 color images, index, order no. 1889.